IMAGES
of America

EASTERN STATE PENITENTIARY

Francis X. Dolan

ARCADIA
PUBLISHING

Published by Arcadia Publishing
Charleston, South Carolina

Printed in the United States of America

Library of Congress Catalog Card Number: 2007922283

For all general information contact Arcadia Publishing at:
Telephone 843-853-2070
Fax 843-853-0044
E-mail sales@arcadiapublishing.com
For customer service and orders:
Toll-Free 1-888-313-2665

Visit us on the Internet at www.arcadiapublishing.com

IMAGES
of America

EASTERN STATE
PENITENTIARY

On the cover: Closed after 142 years of operation, Eastern State Penitentiary reopened as a historic site in 1994. The massive stone structure was once a state-of-the-art facility, but over 20 years of abandonment created a ruin in the center of Philadelphia. (Courtesy of the Eastern State Penitentiary Historic Site Archives.)

CONTENTS

ACKNOWLEDGMENTS

Firstly I would like to thank everyone who continues to keep Eastern State Penitentiary alive. The penitentiary is fortunate to have visitors that truly love the site and are anxious to be a part of everything that is going on inside of the prison today. Without this public support, the prison may have vanished a long time ago. Over the years, many people have volunteered their time and expertise to help make Eastern State Penitentiary the wonderful place that it has become. The future of Eastern State Penitentiary has never looked brighter than it does today.

I especially would like to thank everyone at Eastern State Penitentiary Historic Site for their support during this project: Brett Bertolino for giving me this opportunity and for his Yoda-like wisdom; Jason Ohlsen for his technical expertise and for being an excellent office mate; Sara Jane Elk for being a wealth of post-1971 knowledge; Sean Kelley for helping to move this book in the right direction; Andrea Reidell for her help with fact checking and other pieces of information; Erica Green for her knowledge, assistance, and for dealing with me while I made a mess of the archives; and Kelly Otterson for all of her photography help.

Over the years, countless individuals and families have been generous enough to donate objects to the collection of the historic site. Without them, this book would not exist. Some of the photographs in this book have been donated to the Eastern State Penitentiary Historic Site from Emily Rafter, Mary B. Marden, James J. Farley, Kate Farley, Bernard C. Farley, and John P. Farley; Jack Flynn; Howard James; Richard Fullmer; Joseph Brierly; Joseph H. Mucerino; the family of Lester Smith; Anthony Jacobs; Ray Bednarek; David DiGuglielmo; Leonard Bojanowski; the Correctional Accreditation Managers Association of Pennsylvania (CAMA-PA); and anonymous donors.

On a personal note, I would like to thank my whole family for all of their support and help over the years, especially Mom and Mike. And I would also like to thank Margaret Wentworth and Mike and Katie Lanciano for taking such good care of me.

INTRODUCTION

In October 1829, Charles Williams was admitted to Eastern State Penitentiary as inmate No. 1. The significance of the occasion was most likely lost on Williams, a poor farmer sentenced to two years for stealing a horse, but the rest of the world was paying attention. A state-of-the-art facility, Eastern State Penitentiary immediately attracted interest for its grand architecture and soon-to-be influential radial plan design, modern amenities such as indoor plumbing and heating, and the controversial Pennsylvania System of confinement, designed to bring out the "inner light" of the men and women sentenced to serve time in the imposing castle-like building on the outskirts of Philadelphia. A contest was held to find the architect to construct the facility and the young Englishman John Haviland was chosen, narrowly beating out the much more renowned William Strickland. The building designed by Haviland was one of the most ambitious that the modern world had even seen. The state purchased 12 acres, and almost $800,000 was appropriated for the construction. The seven cell blocks of the prison were completed 14 years later, nestled behind 30-foot stonewalls with a perimeter of a half mile.

Much like the inmates inside of the sky-lit cells, the prison itself was isolated, located approximately two miles outside of the city proper. Built on the site of a former cherry orchard atop a hill, the penitentiary was visible for miles amidst the relatively bare landscape. Seeing the building how it is today—crumbling, ominous, and seemingly abandoned—one can easily imagine the suffering that went on inside of the penitentiary. But this was not the intention. Founded as an alternative to the overcrowded and disease-riddled prisons of the 18th century, Eastern State Penitentiary was the brain child of the Philadelphia Society for the Alleviation of Miseries on Public Prisons. With an agenda even larger than their name, this group truly believed in the inherent goodness of mankind and this new penitentiary was designed to coax it out of each inmate sentenced there. Unfortunately the Pennsylvania System of solitary confinement collapsed under the weight of its lofty ideals as the reality of cost, space, and human nature brought compromise to the prison. At the same time, the city crept northward and swallowed up Eastern State Penitentiary and created an unwelcome resident in a rapidly growing urban area. The escape- and riot-plagued 1920s and 1930s fostered this sentiment, but the prison remained.

The facade of the building was meant to inspire fear and serve as a deterrent towards crime, but the architecture inside told a different story. Cathedral-like barrel-vaulted cell and corridor ceilings conjured up thoughts of second chances and forgiveness for the residents of the prison. Inmates were taught trades with an eye towards reentering society as productive citizens. The system of solitary confinement was difficult to maintain, but the noble vision of reformation and salvation remained as the years passed. Perhaps the most striking image from the early days of the prison is that of the hooded inmate. Certainly macabre, the masked man seems more

akin to a man being brought to the gallows rather than one being shown the way to penitence. Its true intention was to hide the identity of the inmate so as to give them a fair chance at being accepted back into society by shielding their faces from the others in the prison, but like many aspects of the prison, it was overthought by its founders and was ultimately discarded. As the 20th century approached, compromise became the major theme for the prison and the activities inside changed accordingly. Baseball fields and basketball courts replaced the personal exercise yards. Inmates once learned trades inside of their cells and worked alone, but now large workshops housed machinery for use by large groups of inmates. School buildings replaced individual instruction. Eight additional cell blocks were added, blurring Haviland's original vision of a symmetrical, wagon wheel–shaped prison. Most of all, Eastern State Penitentiary truly became a city within a city. Inmates became heavily involved in sporting leagues and formed teams that played full schedules of games, industries thrived, inmates took pride in the work that they were doing, and education once again moved to the forefront of the prison's agenda by the 1960s.

In 1971, after 142 years of operation, the doors of Eastern State Penitentiary were closed, and the building was left behind to fend for itself. Nature reclaimed the site with surprising speed and efficiency, leaving behind the skeleton of one of young America's greatest building projects. An institution that once held the world's attention was now an abandoned ruin in the center of a major American city. For years, it sat unused, passed by thousands of people going about their daily lives. In the late 1980s, demolition attempts were thwarted by the efforts of the Eastern State Penitentiary Task Force, a group of historians, criminologists, neighbors, and preservationists committed to seeing the structure saved. In 1994, Eastern State Penitentiary once again opened its doors, this time as a museum.

It has been said by many visitors to the historic site that it is almost impossible to take a bad picture at Eastern State Penitentiary. With over 1,000 skylights providing natural light for photographs, this is certainly true of the site today, but as *Eastern State Penitentiary* shows, it has always been the case. Almost since its inception, the prison has been well documented by both visitors and staff through photographs and drawings. Heavily weighted with photographs from the 20th century, these documents nonetheless chronicle the growth of the prison as an institution, the lives of the men and women who spent time there, and the rebirth of the penitentiary as a museum and historic site. Today the prison exists as a stabilized ruin. The deterioration of the prison has been frozen in time through conservation efforts, in order to maintain the integrity of the structure, though there is no plan to fully restore the site. The crumbling walls and eerie cell blocks of the prison echo with not only the long history of the prison but also with the voices of the lives spent there.

One

A CITY WITHIN A CITY

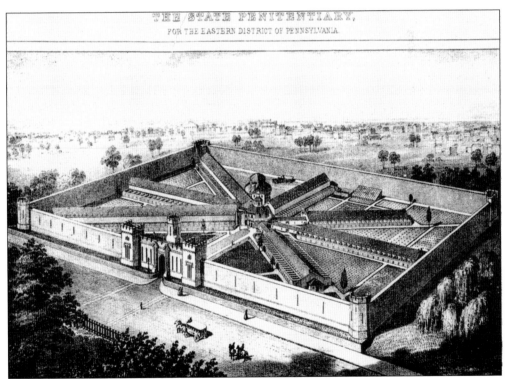

THE STATE PENITENTIARY,
FOR THE EASTERN DISTRICT OF PENNSYLVANIA

This etching from 1855 shows the original seven-cell block design envisioned by the architect John Haviland. This design was completed in 1836, seven years after the prison was opened, and 14 years after construction began. In this facility, 450 inmates could be housed. To the residents of the city, the prison was an ominous sight and a constant reminder of what would happen should one run astray of the law. This etching was made by Samuel Cowperthwaite, inmate No. 2954. How Cowperthwaite obtained such detailed knowledge of the prison's layout is unknown. This image was a gift from Norman Johnston. (Courtesy of the Eastern State Penitentiary Historic Site Archives.)

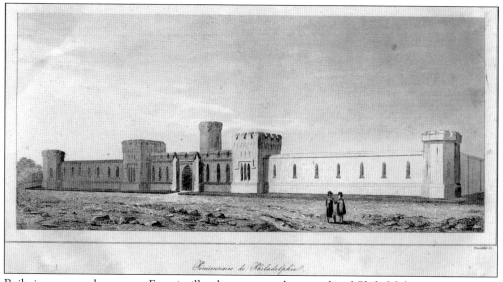

Built in an area known as Francisville about two miles outside of Philadelphia, Eastern State Penitentiary occupied a former cherry orchard that was 12 acres in size. Costing almost $800,000, it was one of the most expensive building projects in the world. The massive stonewalls of the prison are approximately a half mile in length, over 30 feet high, 8 feet thick at the base, and extend another 10 feet underground. (Courtesy of the Eastern State Penitentiary Historic Site Archives.)

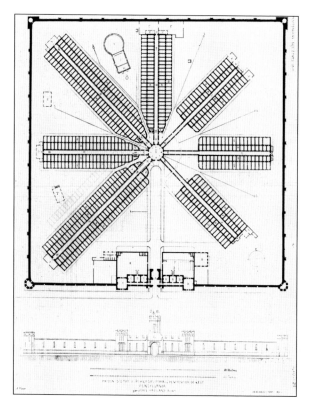

This image is from the book *Rapports sur les penitenciers des Etats-Unis* by Frederic-Auguste Demetz and Giollaume-Abel Blouet. The centrally located observation hub allowed the overseers to monitor the entire building from one spot. This radial design has proven itself to be very influential, spawning over 300 prisons around the world that have copied this "hub and spoke" plan. In addition to the seven cell blocks, the penitentiary also had a stand alone building that served a pump house.

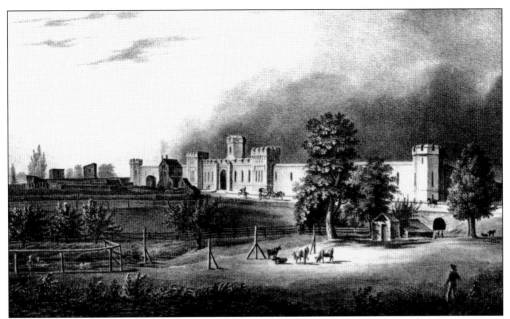

The neo-Gothic facade of Eastern State Penitentiary was designed by architect John Haviland to strike fear into the hearts of those who thought of committing a crime. Built atop a hill, the prison was visible for miles and was in stark contrast to the rural landscape around it. Many of the local residents were immigrants from Europe, and for them, the castle-like structure conjured up thoughts of dungeons and torture, remnants of a feudal system that dominated Europe for a time. This image was from the 1924 annual report.

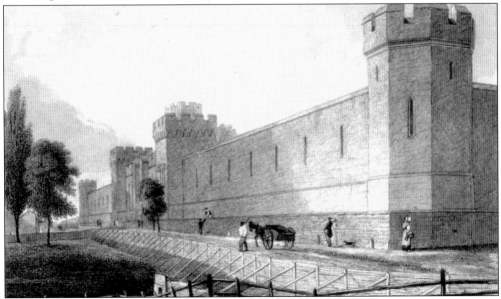

Arrow slit windows adorn the outer walls, and battlements encircle the tops of the towers. However, neither of these features are functional and were intended solely to contribute to the imposing facade of the building. The stone used to build the walls is primarily Wissahickon Schist and Gneiss, which came from quarries in the Philadelphia region. This image was the gift of an anonymous donor. (Courtesy of the Eastern State Penitentiary Historic Site Archives.)

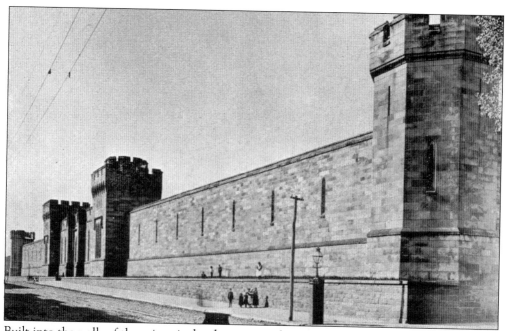

Built into the walls of the prison is the three-story administrative building. Some of the rooms located inside were the warden's office, the original intake facility, laundry, kitchen, hospital, and the residence for the warden and his family. In the 1880s, the warden's office was moved into the prison, only to have it return to the administrative building later on due to security concerns. This is the an early photograph taken of the penitentiary, from around 1897. This image is from the book *Warden Cassidy on Prisons and Convicts* by Michael J. Cassidy.

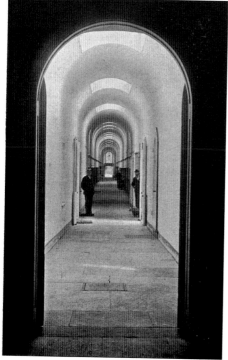

The original one-story cell blocks at Eastern State Penitentiary, cell blocks one through three, were the most luxurious prison facilities in the world. The interior of the prison was designed to resemble a cathedral to inspire penitence, or true regret, in the men and women housed there. Hence the new term, penitentiary. Large barrel-vaulted ceilings and skylights were the norm throughout the facility. This image is from the book *Warden Cassidy on Prisons and Convicts* by Michael J. Cassidy.

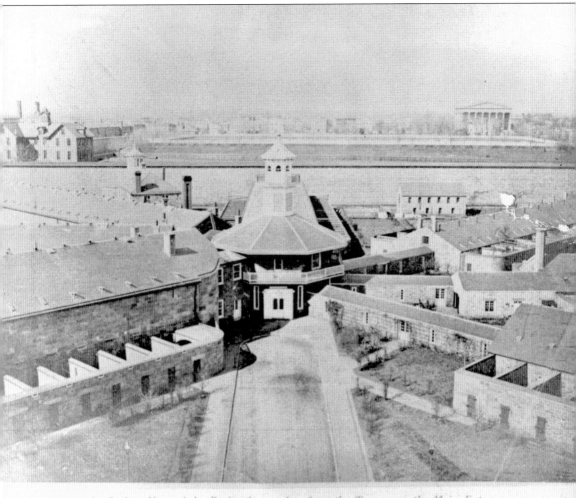

Bird's Eye View of the Penitentiary, taken from the Tower over the Main Entrance.

John Haviland's original design called for seven one-story cell blocks to house inmates. Unfortunately this design only created 256 cells, far short of what the state envisioned. As a result, cell blocks four through seven were constructed with a second floor, called a gallery. The result was that inmates on the gallery were left without exercise yards and those on the first floor had poorly functioning skylights. Compromise was a regular part of Eastern State Penitentiary from the very beginning. This photograph was donated by the John D. Shearer family. (Courtesy of the Eastern State Penitentiary Historic Site Archives.)

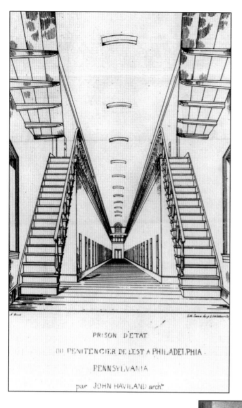

PRISON D'ETAT

OU PENITENCIER DE L'EST A PHILADELPHIA.

PENNSYLVANIA

par JOHN HAVILAND arch.

Completed in 1836, cell block seven was the largest and grandest of all the cell blocks in Eastern State Penitentiary. Confronted with the problem of overcrowding due to limited cells, architect John Haviland was forced to compromise his design of single story cell blocks, resulting in the two-tiered cell blocks of four through seven. Cell block seven contained 136 cells, 68 on each of its two levels. This image is from the book *Rapports sur les penitenciers des Etats-Unis* by Frederic-Auguste Demetz and Giollaume-Abel Blouet.

With the completion of cell block seven, the original construction was finished, and no new cell blocks would be added to the prison until 1877. In the 1830s some women were housed in cell block seven to allow easy access to the laundry facility, which had been built on the first floor of the cell block. In later years, the converted exercise yards contained a tin shop, "hobby shop," a rug weaving shop, a machine shop, and the synagogue. This image is from the book *Warden Cassidy on Prisons and Convicts* by Michael J. Cassidy.

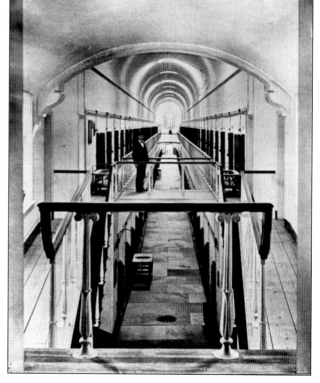

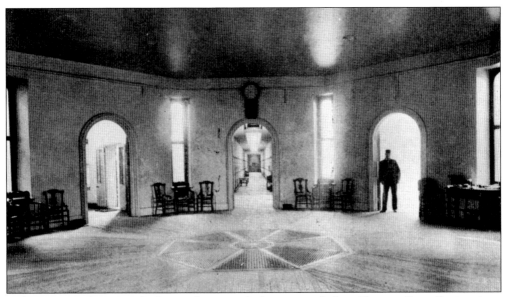

Eight separate doorways feed into the central observation hub at Eastern State Penitentiary, allowing the prison staff to monitor the activity around the 12 acres of the prison grounds. This area became the command center for the guards, and the keys for the whole prison were located in the octagonal room. The idea for the radial plan spawned out of Jeremy Bentham's Panopticon, a prison prototype in which one guard could see directly into every inmate's cell. This image is from the book *Warden Cassidy on Prisons and Convicts* by Michael J. Cassidy.

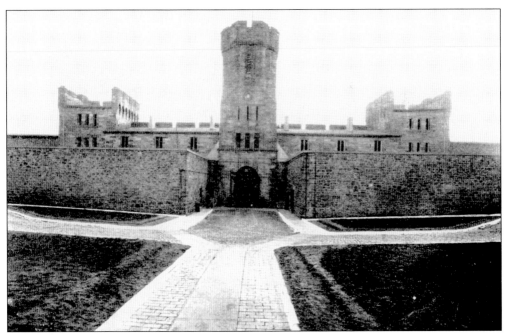

A clear path led from the gatehouse into the central rotunda of Eastern State Penitentiary. In later years, cell blocks eight and nine were constructed, as well as a Bertillon area that housed the intake and parole offices; this location was transformed into a more crowded spot, much like the rest of the prison. This image was from the 1926 annual report.

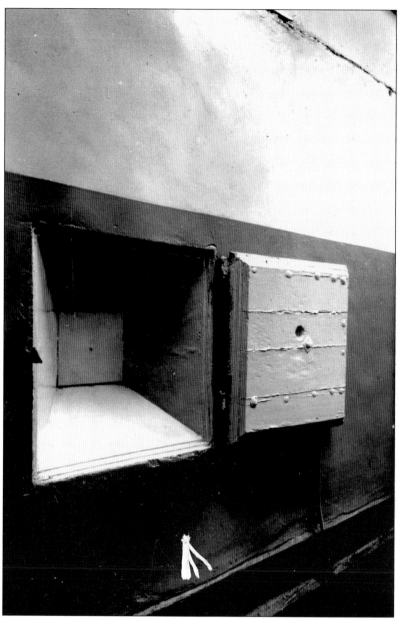

Included in the original design for the cells at Eastern State Penitentiary were small feeding holes instead of doors into the main corridor, all entering and exiting of the cells was done through the rear door leading into the exercise yard. These openings were used by the guards to give not only food to the inmates, but also tools, books, and any other objects a prisoner may require. Food was considered an important part of the rehabilitation process at Eastern State Penitentiary, and the inmates inside the prison enjoyed better food than many of the residents of Philadelphia. Three meals were served daily, and the inmates were given generous servings of meat and vegetables. Dinner was typically boneless beef or pork, soup, and an unlimited amount of potatoes. Inmates were also allotted a pound of bread a day. A menu from the late 1800s lists Tuesday's lunch as bologna, pickles, and shortbread. (Courtesy of the Eastern State Penitentiary Historic Site Archives.)

Eastern State Penitentiary is considered to be the world's first true penitentiary. Most jails and prisons before Eastern State Penitentiary were designed to hold criminals until they were punished for their crimes, but at Eastern State Penitentiary, a system was put in place that would lead the inmates to penitence. The Pennsylvania System, or the Separate System, kept the inmates isolated in their cells 24 hours a day. A skylight provided the inmates' only light. This image is from the book *Brief Sketch of the Origin and History of the State Penitentiary* by Richard Vaux.

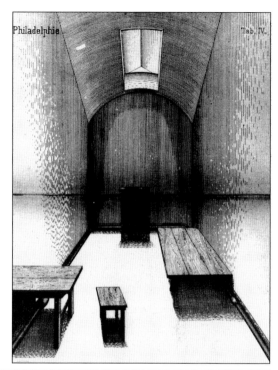

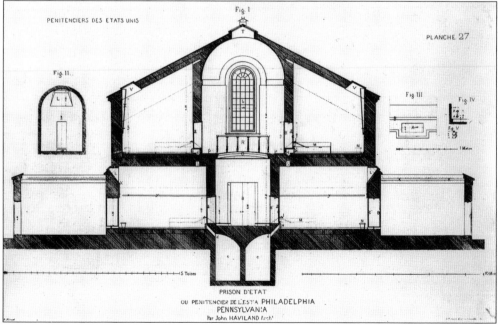

Through the use of religious instruction, job training, and solitary time to contemplate past transgressions, the officials at Eastern State Penitentiary took a humane approach to reform. Inmates were kept in complete solitude in their cells for the duration of their sentence in order to keep them isolated and apart from bad influences. The cells were designed to accommodate all the daily needs of the men and women imprisoned within. This image is from the book *Rapports sur les penitenciers des Etats-Unis* by Frederic-Auguste Demetz and Giollaume-Abel Blouet.

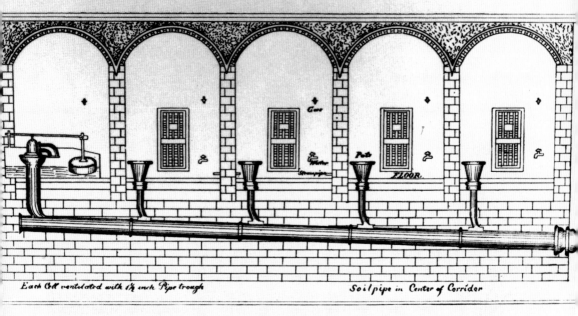

Gas

Pot

Water

FLOOR.

Steampipe

Each Cell ventilated with 1½ inch Pipe trough

Soilpipe in Center of Corridor

DRAINAGE.

This architectural drawing from the book *Warden Cassidy on Prisons and Convicts* by Michael J. Cassidy shows the drainage design for the one-story cell blocks at the prison. All of the toilets emptied into the same drainage pipe, which gradually sloped downward into a singular reservoir. Eastern State Penitentiary was one of the first large scale buildings in the world to have indoor plumbing. At a time when Pres. Andrew Jackson was using a chamber pot, the inmates at Eastern State all had their own personal toilets.

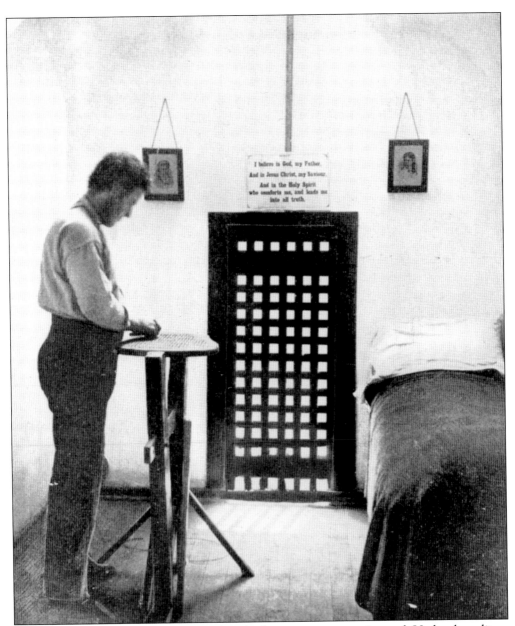

Located in the rear of each cell was a door leading out to an exercise yard. Under the solitary confinement system, inmates were allowed out in these yards for one hour a day, broken into two half-hour increments. It was not at the discretion of the inmate when they would exercise, but the overseers would inform them it was time. The yards were open to the sky in order to get some fresh air to the prisoners, but this also created a security threat. Because of this, inmates were never allowed to exercise at the same time as their neighbors to ensure that they were not communicating over the walls. The yards were also searched by the overseers before the inmate entered and after they exited. This image is from the book *Warden Cassidy on Prisons and Convicts* by Michael J. Cassidy.

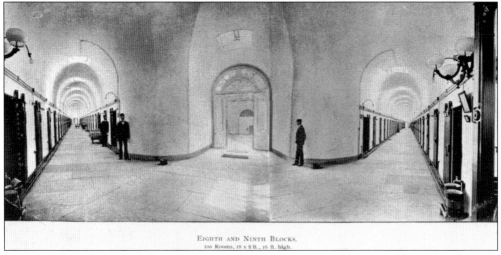

EIGHTH AND NINTH BLOCKS.
100 Rooms, 18 x 8 ft., 16 ft. high.

In 1877, cell blocks eight and nine were completed, marking the first time additional cell blocks had been added onto the original John Haviland design. These cell blocks were designed by warden Michael Cassidy. Cassidy had started at Eastern State Penitentiary as a carpenter. The cells in cell blocks eight and nine were larger than the cells in the original blocks, but were also built without exercise yards. Inmates in these cells would be hooded and exercised in a large outdoor area within the prison, unable to see the other inmates around them. This image is from the book *Warden Cassidy on Prisons and Convicts* by Michael J. Cassidy.

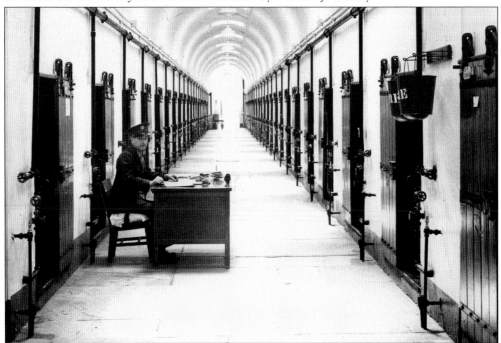

Even though Eastern State Penitentiary would not officially adopt the congregate system until 1913, the cells in cell block eight and nine were capable of housing multiple inmates, as shown by the two skylights in each cell. The barrel-vaulted ceilings and church-like interior established by Haviland were continued by Cassidy in these later cell blocks. This image was donated by Lt. Jack Skelton. (Courtesy of the Eastern State Penitentiary Historic Site Archives.)

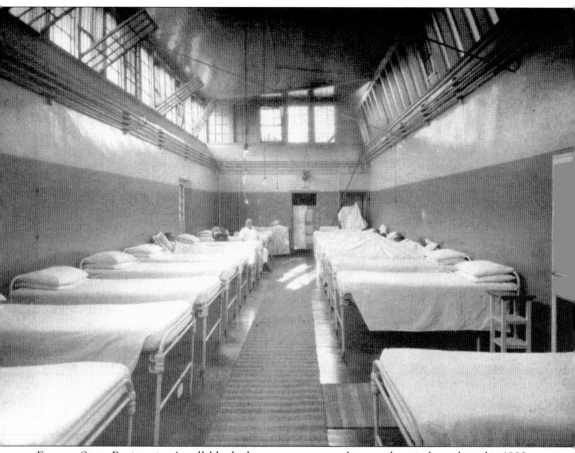

Eastern State Penitentiary's cell block three was converted into a hospital ward in the 1880s to address the growing needs of the crowded prison. Over the years, it became a very modern facility equipped with an X-ray room, operating room, and specially designed cells to promote health in inmates stricken with tuberculosis. In the 1920s, some inmates were even offered an opportunity to undergo cosmetic plastic surgery in an attempt to make them seem friendlier and nicer to the society that they had wronged. This photograph from 1925 shows the recovery room. This image was from the 1925 annual report.

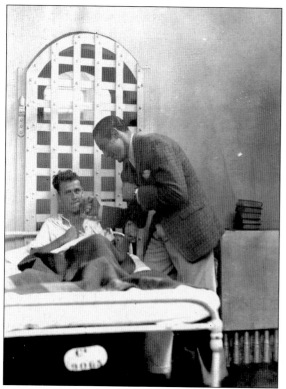

An inmate recovers in the hospital wing at the penitentiary with the help of a well-wisher. Despite being a functional hospital, Eastern State Penitentiary was first and foremost a prison, as evidenced by the metal lattice door behind the inmate. This image was donated by Emily Rafter, Mary B. Marden, James J. Farley, Kate Farley, Bernard C. Farley, and John P. Farley. (Courtesy of the Eastern State Penitentiary Historic Site Archives.)

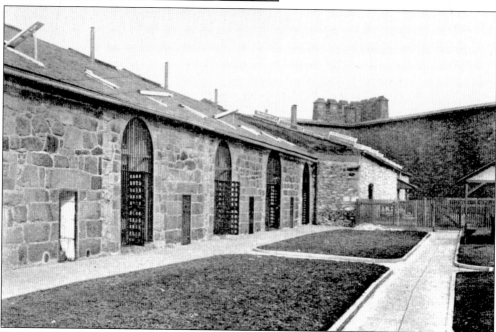

Some of the cells constructed in the hospital had grated metal fencing in the rear of the cell to allow for better air circulation. Called cells for consumptives, these areas were used to treat inmates that had contracted tuberculosis. Doctors thought that the fresh air provided by these back doors would be beneficial for their condition. This image was from the 1905 annual report.

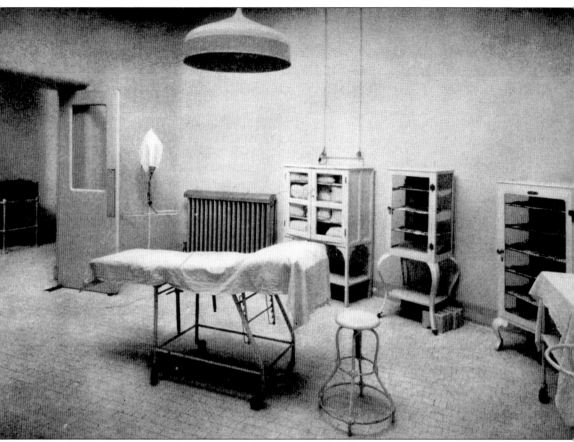

With the modernization of the hospital ward in the 1920s, a full-scale operating room was built in the former exercise yards of cell block three. The prison staffed a medical crew and also worked with physicians from local hospitals and universities. The medical staff kept busy tending to illnesses and injuries, as well as the effects of inmate violence against one another. In 1929, inmate Al Capone had his tonsils removed in the operating room. This image was from the 1923 annual report.

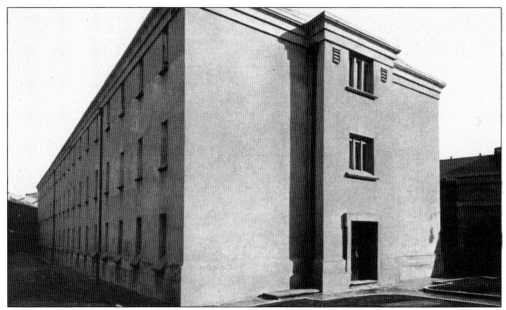

Completed in 1911, cell block 12 was the first three-story cell block, showing the need for more cell capacity as larger numbers of inmates were brought into the prison in the 20th century. Each level of the cell block contained 40 cells, contributing 120 cells to the prison's total of 885 at the time. The earliest cells at the prison were spacious rooms with grand vaulted ceilings, reflecting the lofty mind-set of the founders and the hope for individual reform in each prisoner. These smaller, less decorative cells reflect the abandonment of the founders' optimism. This image was from the 1913 annual report.

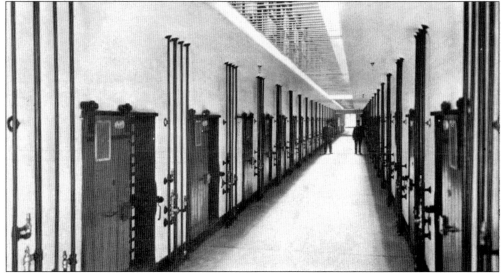

In contrast to the previous cell blocks, the cold concrete walls and tiny cells of cell block 12 show the transformation of Eastern State Penitentiary into a crowded facility whose main concern was containing the increasingly hostile and violent inmates housed inside. The cells in cell block 12 did not contain skylights, but rather small slit windows in the back wall, further blurring the connection to the prison's past and the solitary system of penitence imagined by the prison's founders. This image was from the 1920 annual report.

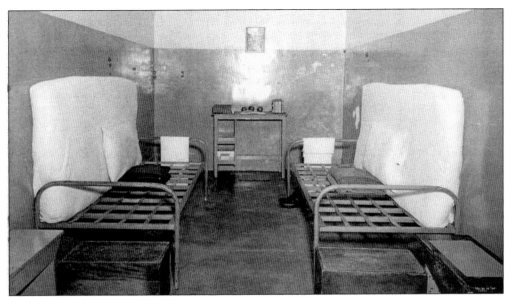

With the abandonment of the solitary confinement system in 1913, Eastern State Penitentiary became a congregate prison. In addition to overcrowding, one of the major factors for this conversion was the cost of running a solitary prison. Since inmates were supposed to be kept inside of their cells for the duration of their stay, they were unable to perform work around the prison. This photograph was a gift from Jack Flynn. (Courtesy of the Eastern State Penitentiary Historic Site Archives.)

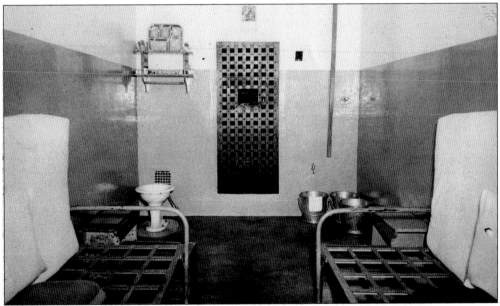

Many prisons are able to save money by having inmates work in the kitchens, do maintenance around the prison, work in the laundry, and most other jobs. At Eastern this was not possible and the cost of outside contractors became a prohibitive factor in maintaining the system of isolation. Under the new congregate system, inmate work branched out to all areas, even the construction of new cell blocks. This photograph was donated by Jack Flynn. (Courtesy of the Eastern State Penitentiary Historic Site Archives.)

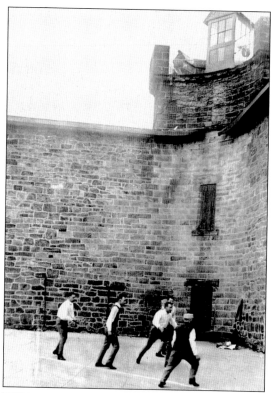

Under the watchful eye of warden John C. Groome, security at Eastern State Penitentiary was improved in the 1920s. In response to several escapes, including the one by Leo Callahan, Groome replaced the majority of the guard staff and brought in many former military men to take their jobs. Small wooden sentry boxes that were built atop the corner towers were replaced by sturdier brick towers, creating a safer atmosphere for all the staff at the prison. (Courtesy of Pennsylvania State Archives.)

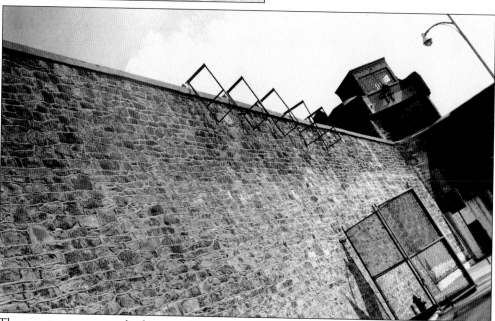

These new towers were also home to Kragg repeating rifles and Thompson submachine guns for the guards. Inside the prison, metal headgates were constructed in each cell block to prevent inmates from reaching the central command center. The inmate visitation area was moved to the front building to limit the number of visitors inside of the prison. This photograph was donated by Jack Flynn. (Courtesy of the Eastern State Penitentiary Historic Site Archives.)

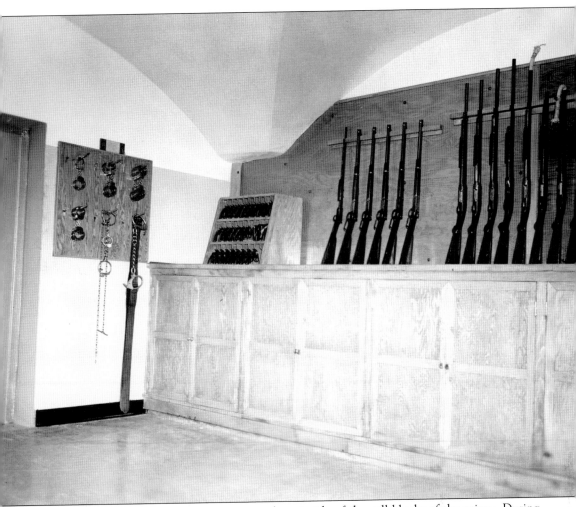

Due to security concerns, guns were never kept inside of the cell blocks of the prison. During the 1920s, guards stationed in the prison's towers were given machine guns and rifles, but the guards patrolling the cell blocks were restricted to carrying nothing more than night sticks. This armory is located on the east side of the prison's administration building, close enough to the guards that the weapons were accessible but also far enough to be out of reach from the inmates. This image was a gift from Jack Flynn. (Courtesy of the Eastern State Penitentiary Historic Site Archives.)

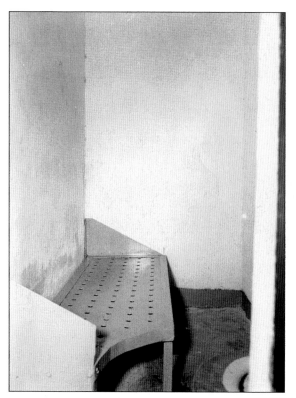

Cell block 13 was the first part of the prison to be built exclusively for solitary confinement as a form of punishment. Completed sometime between 1911 and 1926, cell block 13 is nothing more than 10 cramped cells built along the northeast wall of cell block 10. The conditions in these cells were particularly harsh; they measured four by eight feet with an eight-foot high ceiling. This photograph was donated by the family of Capt. Andreas Scheerer. (Courtesy of the Eastern State Penitentiary Historic Site Archives.)

Each cell in cell block 13 contained an iron bed, a hole for ventilation, and no source of light. A radiator in each cell could be turned up to high and was occasionally used to punish the inmates inside. Inmates could be kept inside for upwards of 30 days, depending on the infraction that landed them there. In 1953, a state investigation recommended these cells be eliminated and with the completion of cell block 15 in 1959, 9 of the 10 punishment cells in cell block 13 were destroyed. This photograph was donated by the family of Capt. Andreas Scheerer. (Courtesy of the Eastern State Penitentiary Historic Site Archives.)

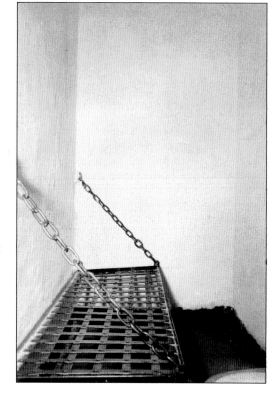

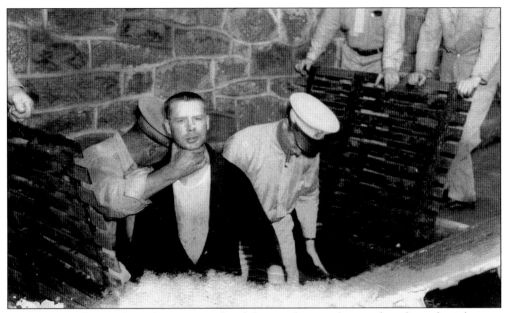

For inmates at Eastern State Penitentiary that did not wish to conform to the rules and regulations, there were always separate punishment cells used by the prison officials. During the solitary confinement years, they were called "dark cells." These were mainly cells on the gallery level of cell block four in which the walls had all been painted black and the skylights covered up. This created an entirely dark environment in which the inmate could ponder his transgressions. This image was donated by Emily Rafter, Mary B. Marden, James J. Farley, Kate Farley, Bernard C. Farley, and John P. Farley. (Courtesy of the Eastern State Penitentiary Historic Site Archives.)

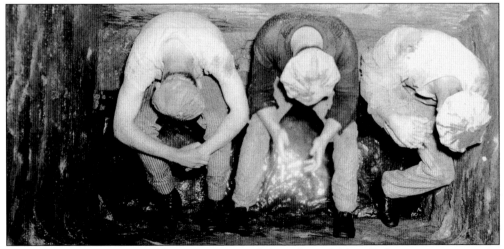

Overcrowding during the 20th century required that all available cells house inmates, so the prison officials looked downward for the new punishment cells. When cell block 14 was completed in 1927, four underground punishment cells known as "Klondike" were built into its foundation. These windowless cells were nothing more than concrete tombs below the ground that inmates would sometimes spend weeks in. Eventually inspectors from the state barred prison officials from using these cells. This image was donated by Emily Rafter, Mary B. Marden, James J. Farley, Kate Farley, Bernard C. Farley, and John P. Farley. (Courtesy of the Eastern State Penitentiary Historic Site Archives.)

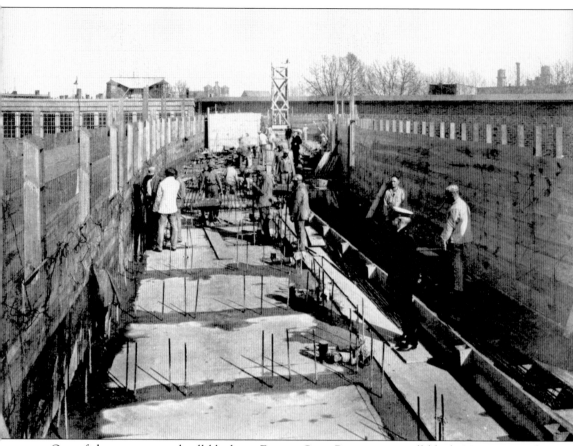

One of the most unusual cell blocks at Eastern State Penitentiary, cell block 14 was not only built by inmates, but it was also designed by an inmate. A Harvard educated architect convicted of passing forged checks was given the job of creating a cell block that would be capable of meeting the increased demands of a prison that was growing to be extremely crowded by the late 1920s. Divided amongst its three stories are 112 cells, making it one of the most crowded cell blocks in the prison. This image was from the 1926 annual report.

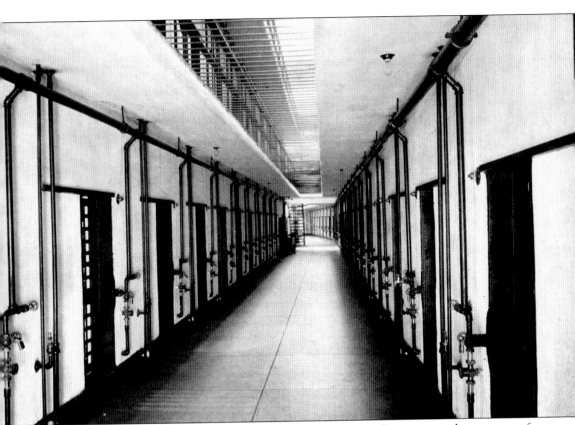

The reinforced concrete that composes the cell block stands in stark contrast to the cut stone of the previous blocks. Very little space was available in the prison complex when cell block 14 was built, forcing it into an alleyway between blocks 3 and 11. It also has a curved layout, rendering the observation of the radial plan completely obsolete. By the 1950s, this block was being used as a state classification facility and to house young and first time offenders. When the prison was closed in 1971, this cell block was already beginning to deteriorate. This image was from the 1927 annual report.

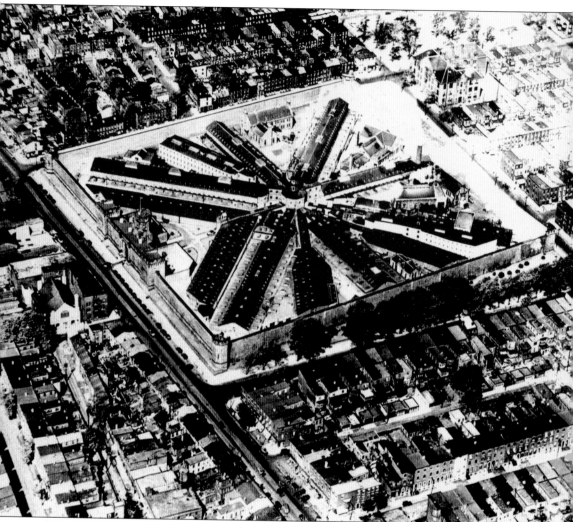

By 1925, the wagon wheel design envisioned by architect John Haviland had been transformed into a cluttered maze of buildings, cell blocks, alleyways, and yards. A prison that was built to hold 250 inmates was now housing almost 1,800, necessitating the construction of seven additional cell blocks. A 15th and final cell block would be completed in 1959. The city of Philadelphia had transformed as well and now crept right up to the walls of the penitentiary. This image was a gift of an anonymous donor. (Courtesy of the Eastern State Penitentiary Historic Site Archives.)

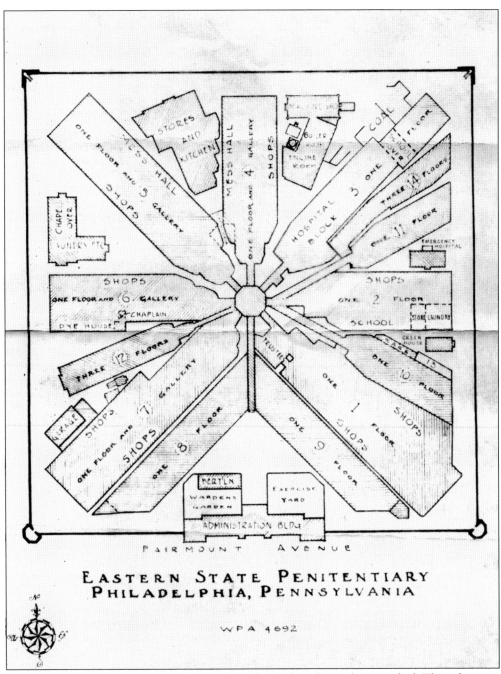

As the prison grew and expanded, the needs of the facility changed a great deal. This schematic from 1936 lists several buildings that were never envisioned by John Haviland, the original architect. An engine room and a boiler room occupy the yard between cell blocks three and four, and a garage juts out from the west side of cell block seven.

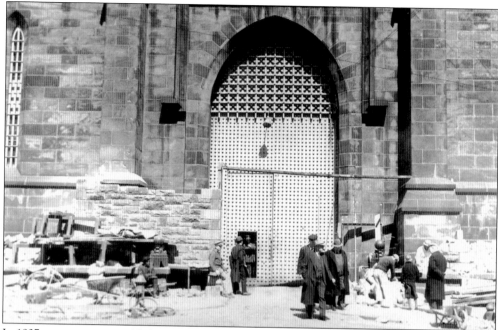

In 1937, a structure was added to the front of the building to heighten security in the increasingly dangerous and violent prison. The addition, known as a barbican in medieval castles, was built from stone that was salvaged from the Emergency Hospital. (Courtesy of Temple University Libraries, Urban Archives, Philadelphia, Pennsylvania.)

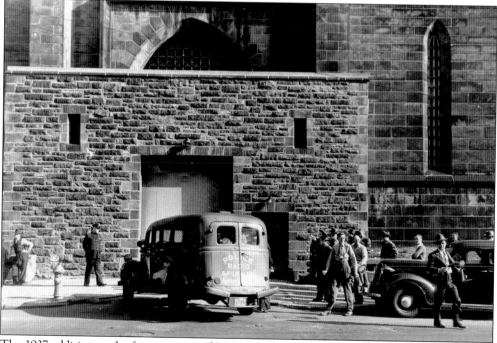

The 1937 addition to the front gate cost $25,000 to build. A studded wooden door was replaced by a large metal one, which could be electrically opened from the inside. (Courtesy of Temple University Libraries, Urban Archives, Philadelphia, Pennsylvania.)

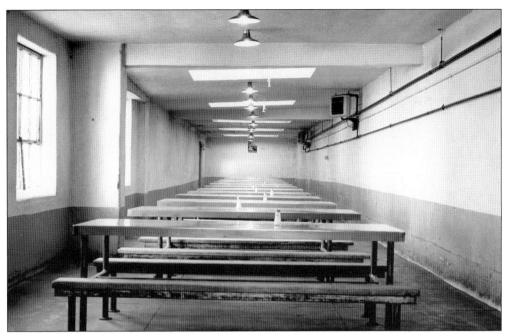

With the collapse of the solitary confinement system, inmates were no longer eating meals in their cells. To accommodate this, long and narrow dining halls were constructed in the former exercise yards of cell blocks four and five, which were no longer in use. These long, narrow spaces greatly limited the ability of the guards to monitor the areas. This image was a gift from Howard H. Haines, captain of the guards. (Courtesy of the Eastern State Penitentiary Historic Site Archives.)

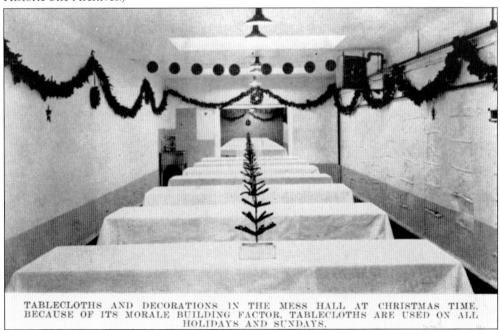

TABLECLOTHS AND DECORATIONS IN THE MESS HALL AT CHRISTMAS TIME. BECAUSE OF ITS MORALE BUILDING FACTOR, TABLECLOTHS ARE USED ON ALL HOLIDAYS AND SUNDAYS.

The dining halls of Eastern State Penitentiary are seen here decorated for the holidays. This image was from the *Eastern Correctional Diagnosis and Classification Center*, 1954.

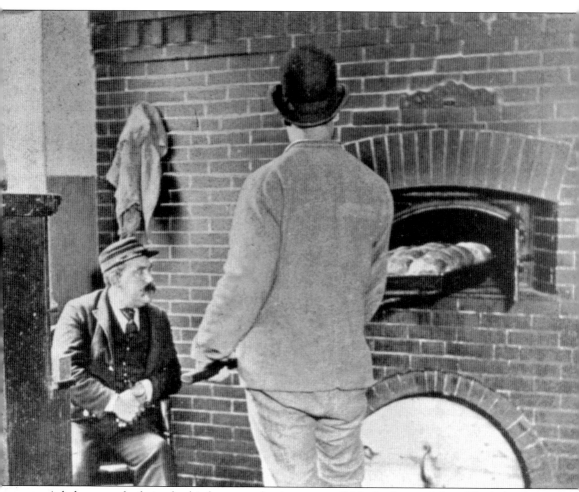

A bakery was built in the kitchen complex between cell blocks four and five. The bakery at Eastern State Penitentiary provided bread for several state prisons in Pennsylvania, and a large weigh station in front of the kitchen ensured that the proper amount was being shipped out of the penitentiary. This image is from the book *Warden Cassidy on Prisons and Convicts* by Michael J. Cassidy.

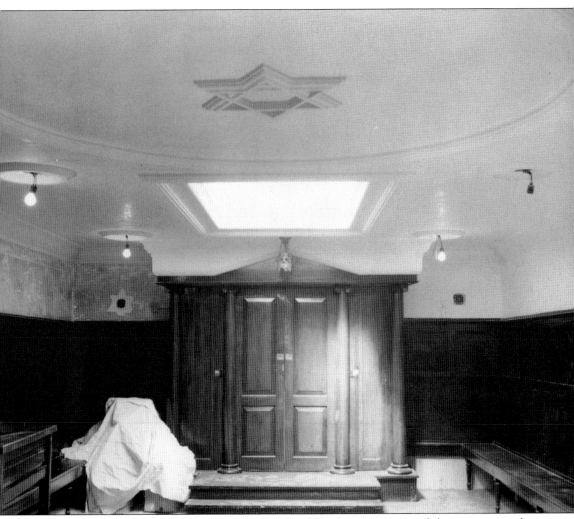

Hidden away inside the former exercise yards of cell block seven is one of the most unusual structures at Eastern State Penitentiary, a synagogue. Built in the early 1920s to accommodate the religious needs of the Jewish population, the synagogue was the product of a combined effort of the penitentiary and leaders from the local Jewish community in Philadelphia. Much of the actual construction was done by the inmates themselves and by volunteers from outside the prison. In 1928, the synagogue was dedicated to Alfred Fleisher, who had served as the president of the board of trustees of Eastern State Penitentiary from 1924 until 1928. Fleisher passed away in 1928, and the inmates erected a plaque in his honor. This photograph was donated by Howard H. Haines, captain of the guards. (Courtesy of the Eastern State Penitentiary Historic Site Archives.)

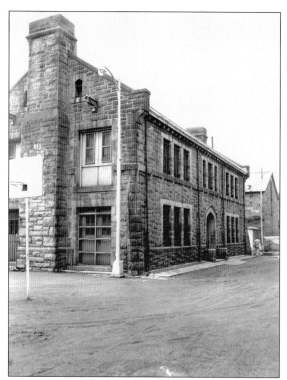

In 1904, an industrial building was completed on the west side of the prison between cell blocks five and six. The first floor of this building housed various workspaces, most notably the laundry and hosiery manufacturing, as well as the prison commissary for a time. The second floor was set aside as a meeting space, and over time, it accommodated a large variety of inmate needs. This photograph was donated by the family of Capt. Andreas Scheerer. (Courtesy of the Eastern State Penitentiary Historic Site Archives.)

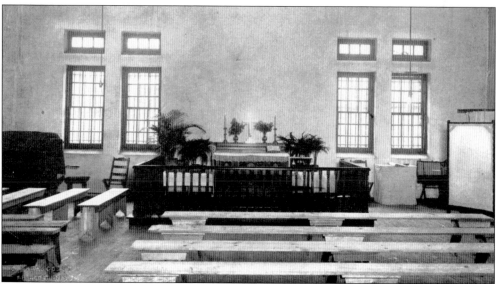

In April 1914, shortly after the prison became congregate, the industrial building was host to a Catholic service. By 1927 Catholic, Episcopalian, and non-sectarian services were all being held in the industrial building. A large metal box that held a film projector was built outside the building's south wall to minimize the risk of fire. Other activities conducted on the second floor were lectures, various entertainment acts, and a gymnasium. This multi-use facility is one of the best examples of the type of changes Eastern State Penitentiary was forced to make in order to accommodate an amount of prisoners never envisioned by the building's architect. This image was from the 1925 annual report.

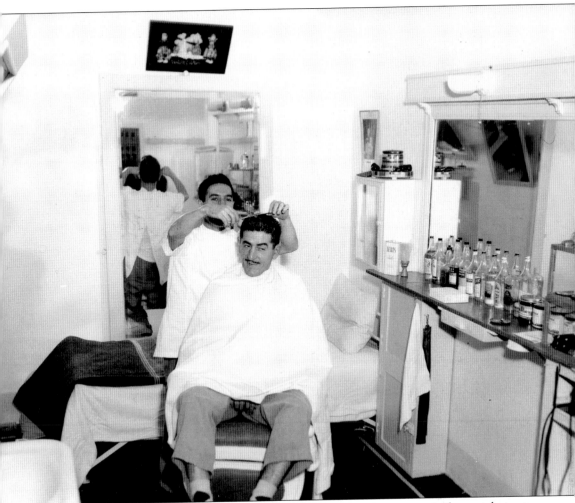

When Eastern State Penitentiary first opened in 1829, inmates were required to get haircuts during intake. In the congregate years of the prison, each of the cell blocks was fitted with a barbershop for the inmates housed on that block. Inmates were trained to be barbers and gave cuts to both inmates and guards. The razors they used were signed out to make sure that none of them disappeared. This photograph was donated by the family of Capt. Andreas Scheerer. (Courtesy of the Eastern State Penitentiary Historic Site Archives.)

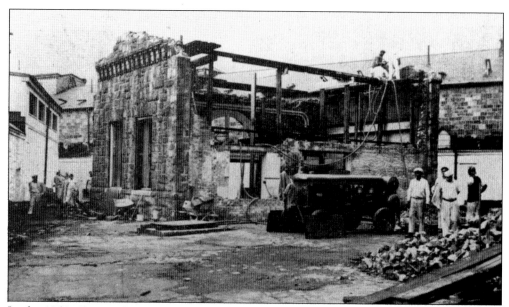

In the 1950s, Eastern State Penitentiary began, for the first time, to purchase energy from the City of Philadelphia. This change made the prison's engine room obsolete and as a result it was demolished. The building was located between cell blocks three and four and the resulting vacant space was turned into a larger athletic field. This image was from the *Eastern Correctional Diagnosis and Classification Center*, 1954.

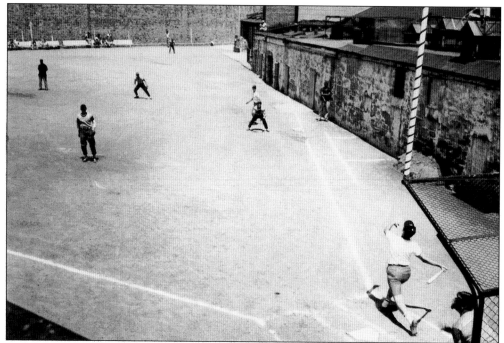

Previously the baseball field occupied a smaller portion of the same lot. Unfortunately the concrete foundation of the building remained, creating a hazardous environment for the prisoners to play sports. This image is a gift from Jack Flynn. (Courtesy of the Eastern State Penitentiary Historic Site Archives.)

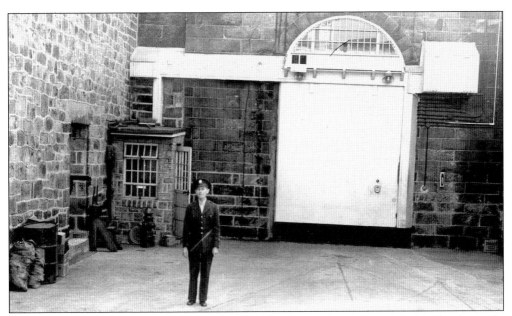

The massive gate of the prison remains closed under the watch of officer John Rafferty in 1951. The gatehouse entrance into the prison consisted of three separate gates, none of which would be open at the same time as any other one, thus creating a lock system for security. This is the only break in the walls of the prison and the only way in and out of the complex. Glass panels above the gate reveal a small station for the guards to monitor and inspect each vehicle that passes through. This image was donated by Dr. Richard Fulmer of Millersville University. (Courtesy of the Eastern State Penitentiary Historic Site Archives.)

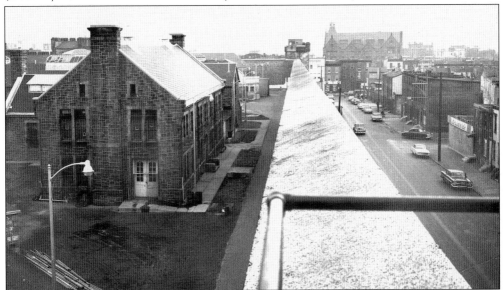

The west wall of the prison partitions the city from the dangerous inmates dwelling inside. As early as the 1920s, some people were demanding that Eastern State Penitentiary be closed, and by the 1950s, calls for the closing of the prison had reached a clamor after the escape-plagued 1940s. The prison's location in the city was a major factor in the closing of the facility in 1971. This image was a gift from Alan LeFebvre. (Courtesy of the Eastern State Penitentiary Historic Site Archives.)

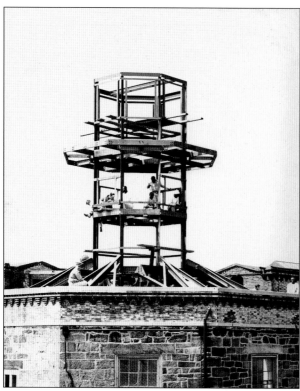

Visible from most locations inside of the prison, the central guard tower dominates the landscape within the walls. This modern metal tower was not built until the 1950s, prior to this a smaller "walkaround" and a wooden tower existed that served the same purpose but was not nearly as effective. This tower rises to almost 70 feet in height in order to allow the guards to keep an eye on the crowded facility without being exposed to the inmate population. This photograph was donated by the John D. Shearer family. (Courtesy of the Eastern State Penitentiary Historic Site Archives.)

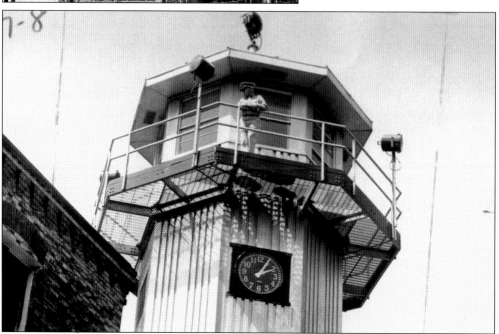

Manned 24 hours a day by guards with spotlights and rifles, the central tower was a stalwart sentinel that kept the inmates under a constant watch. Clocks built into the north and south sides marked the slow passage of time to inmates laboring in the yards below. (Courtesy of Temple University Libraries, Urban Archives, Philadelphia, Pennsylvania.)

Opened in 1959, Eastern State Penitentiary's cell block 15 was also known as "Death Row." The two-story stone structure housed some of the most dangerous inmates in the prison and served as punishment for misbehaving inmates. Upon the opening of cell block 15 in April 1959, the punishment cells of cell block 13 were no longer used. Though called Death Row, executions were not performed at Eastern State Penitentiary. Inmates would be transferred to the State Correctional Institute at Rockview. Equipped with doors that were electrically opened and closed, cell block 15 was considered to be the only modern cell block in the prison. This photograph was a gift from Jack Flynn. (Courtesy of the Eastern State Penitentiary Historic Site Archives.)

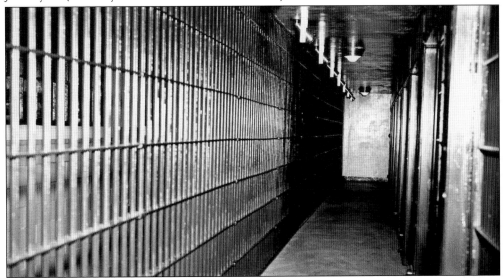

Cell block 15 was constructed with a private exercise yard, built between cell blocks 2 and 11. The inmates inside of Death Row would not receive yardout with the other inmates, but rather were restricted to this small space. This yard is even equipped with a small watchtower to enable guards to monitor the space without coming into contact with the inhabitants below. The interior of the cell block was divided into two corridors, one for inmates and the other for guards. This photograph was a gift from Jack Flynn. (Courtesy of the Eastern State Penitentiary Historic Site Archives.)

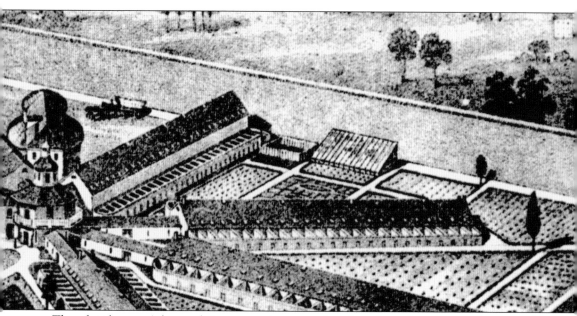

Though it has moved several times over the years, there has always been a greenhouse on the grounds of Eastern State Penitentiary. Initially it was located in the yards between cell blocks 3 and 4 and found its final resting spot nestled between cell blocks 2 and 10. Primarily an agricultural tool, the greenhouse was used to educate inmates in a job skill in the hopes they could find work once they were released. Working in the greenhouse was often a reward for good behavior. Sometimes flowers from the greenhouse were sold to the public and to members of the staff.

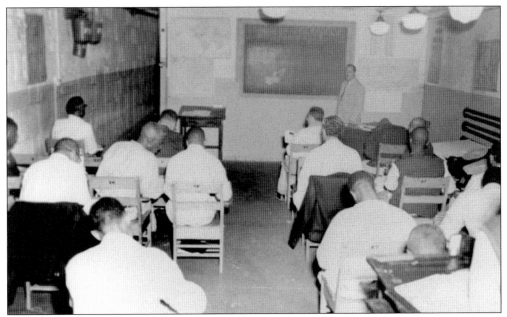

Education was always an important part of the reformation of the inmates at Eastern State Penitentiary. In the earliest days of the prison, inmates were taught a trade that they could perform in their solitary cells; cobbling, weaving, and caning were among the most common. As the population of the prison increased, further demands were placed on the prison and new classroom buildings were constructed, such as the one seen here that was built above cell block one. Motivated inmates could receive their high school diplomas and study law in the prison. (Courtesy of Temple University Libraries, Urban Archives, Philadelphia, Pennsylvania.)

In the early 1960s, warden William Banmiller brought a humanist approach to one of Pennsylvania's toughest prisons and placed an emphasis on welfare, reform, and education. He created more classrooms and relaxed some of the prison's rules, believing that in order to get inmates to act like humans they had to be treated like humans. This photograph was donated by the family of Capt. Andreas Scheerer. (Courtesy of the Eastern State Penitentiary Historic Site Archives.)

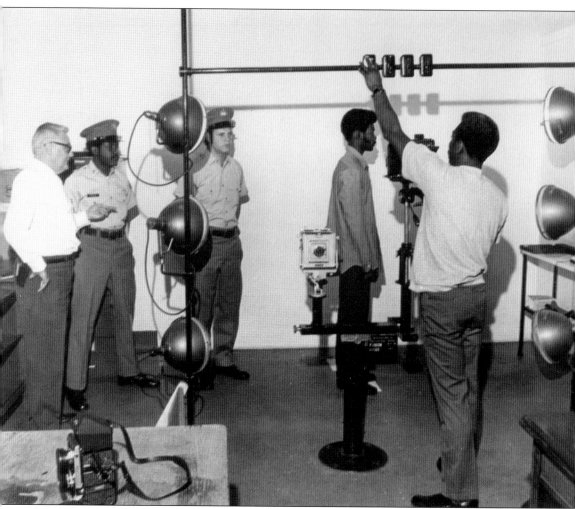

In 1970, Eastern State Penitentiary, then known as the State Correctional Institution at Philadelphia, closed its doors to state inmates for the final time. The building had been in operation for 141 years and was clearly outdated by the standards of the day. The inmates in this picture are being photographed before transfer to other prisons. They were the last state prisoners ever housed in the facility. (Courtesy of Pennsylvania State Archives.)

Two

THE FACES OF EASTERN STATE PENITENTIARY

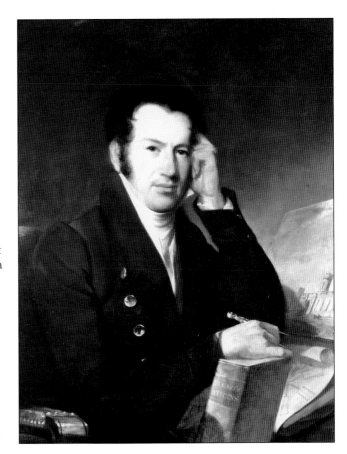

John Haviland was a young British architect when he won the commission to design Eastern State Penitentiary. Just 30 years old when construction began, Haviland would go on to be one of the most successful architects working in the Philadelphia area and a pioneer of American neoclassical architecture. He also designed the original Franklin Institute and the Pennsylvania Institution for the Education of the Deaf and Dumb. (Courtesy of the Metropolitan Museum of Art.)

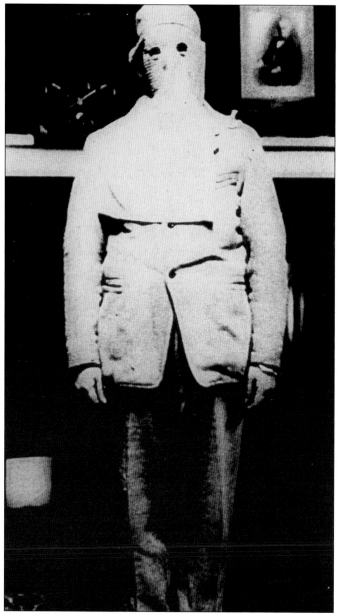

In order to create an experience of total isolation, inmates at Eastern State Penitentiary were hooded when first brought into the prison and anytime that they left their cells. Despite their macabre appearance, the officials used these hoods for what they considered to be a humane reason. By keeping the identity of the inmates unknown it was thought they would stand a better chance of being accepted into society when their sentence was finished and the inmate released because no one would have recognized them during their stay at the prison. The original, eyeless hoods also had the added effect of keeping the inmates in the dark about the layout of the prison. Should an inmate attempt an escape, they would be unfamiliar with the design of the building. Officially the practice of hooding inmates ended with the adoption of a congregate policy in 1913. This photograph was donated by the John D. Shearer family. (Courtesy of the Eastern State Penitentiary Historic Site Archives.)

In an attempt to move away from cruel forms of treatment, corporal punishment was not allowed at Eastern State Penitentiary. Reduction of food and loss of exercise time were the approved forms of discipline at the penitentiary. However, in 1831 inmate Seneca Plimly was subjected to the shower bath, a way of dumping buckets of cold water on a person, and released from the prison shortly after for being incurably insane. (Courtesy of the Eastern State Penitentiary Historic Site Archives.)

Eastern State Penitentiary was founded to move away from forms of torture like the pillory, whipping, and the stocks. Perhaps no device was feared more than the iron gag. A metal brace was inserted into the mouth of the inmate with chains attached to the wrists; the more the inmate struggled the tighter the device became. In 1835, there was an investigation into the death of an inmate who supposedly died when in this device. Prison officials were exonerated of any wrongdoing. (Courtesy of the Eastern State Penitentiary Historic Site Archives.)

In 1842 Eastern State Penitentiary was visited by the prolific English author Charles Dickens. Dickens was given access to some inmates and recorded his feelings on the prison in his book *American Notes*. Unlike most Europeans, Dickens was critical of the Pennsylvania System. He wrote, "The system here, is rigid, strict, and hopeless solitary confinement. I believe it, in its effects, to be cruel and wrong. I hold this slow, and daily, tampering with the mysteries of the brain to be immeasurably worse than any torture of the body." This image is from the book *Pictures from Italy and American Notes for General Circulation* by Charles Dickens.

The life of a guard at Eastern State Penitentiary was far from easy. In the 19th century, the overseers worked in excess of 12 hours a day, 6 days a week. Frequently the target of animosity from the inmate population, these feelings sometimes resulted in violence. In 1884, inmate Joseph Taylor, No. A-1483, used a metal bar to bludgeon overseer Michael Doran to death. This image was the gift of an anonymous donor. (Courtesy of the Eastern State Penitentiary Historic Site Archives.)

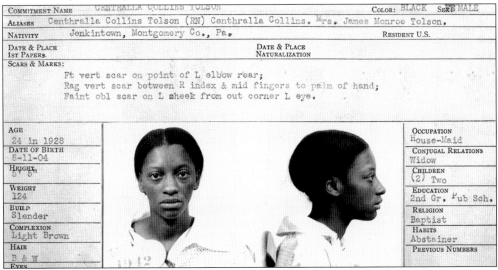

L 12143-10									

AGE 23 YEARS **DATE OF BIRTH** April 12, 1891 **NATIVITY** Winston, NC **SEX** FEMALE.

RESIDENT IN U.S. YEARS **TAKEN OUT FIRST PAPERS** **NATURALIZED** **BUILD** Stout

COMPLEXION Med Mulatto **EYES** Dk Maroon **HAIR** B&W **FOOT** 9¾

STATURE 5 **FT.** 2 **IN.** **WEIGHT** 161 **INDUSTRIAL RELATIONS** Unapprenticed

OCCUPATION House work **WORKING WHEN ARRESTED** No **HOW LONG BEFORE, IF NOT** 1 year

PARENTAL AT 16 YEARS FATHER Living **MOTHER** Living **AGE ON LEAVING HOME** 17 YEARS

EDUCATIONAL: READS AND WRITES Yes **PUBLIC SCHOOL** 4 YEARS **PRIVATE SCHOOL** YEARS **AGE ON LEAVING** 13 YEARS

HABITS: Abstainer **ASSOCIATES:** Ordinary **RELIGION:** Protestant **SMOKE:** No **CHEW:** No

ATTRIBUTE CRIME TO DRINK: Yes **PROFANITY:** No **CONJUGAL RELATIONS:** Single

CHILDREN: **LIVING WITH WIFE OR HUSBAND:** **CASH:** None **DOLLARS** **CENT**

PROPERTY: None

MARKS AND SCARS Small rnd dep scar above root of nose: same near out cor of right eye. sev brown moles on point of chin.

COLOR: Black **COUNTY:** Dauphin **TERM:** 27 January 1915 19

CRIME Larceny from the person.

SENTENCE: MIN: 1 **YRS.** **MOS. MAX.** 2 **YRS.** **MONTHS**

FINE: $ 5.00 **REMARKS:** **JUDGE:** McCarrell

DATE OF SENTENCE January 12, 1915 19 **DATE RECEIVED** January 20, 1915 19

NAME Rebecca Thomas **ALIASES**

ADDITIONAL TIME TO BE SERVED

One of the many challenges of housing women in a predominately male facility was keeping apart members of the two sexes. Women were segregated from the men by keeping them confined to certain cell blocks. Despite the solitary confinement system and the relatively small number of female inmates, encounters between the two were unavoidable. This was donated by the Capt. Andreas Sheerer family. (Courtesy of the Eastern State Penitentiary Historic Site Archives.)

COMMITMENT NAME CENTHRALLA COLLINS TOLSON **COLOR:** BLACK **SEX** MALE

ALIASES Centhralla Collins Tolson (RN) Centhralla Collins. Mrs. James Monroe Tolson.

NATIVITY Jenkintown, Montgomery Co., Pa. **RESIDENT U.S.**

DATE & PLACE 1ST PAPERS. **DATE & PLACE NATURALIZATION**

SCARS & MARKS:
Ft vert scar on point of L elbow rear;
Rag vert scar between R index & mid fingers to palm of hand;
Faint obl scar on L cheek from out corner L eye.

AGE 24 in 1928 **OCCUPATION** House-Maid

DATE OF BIRTH 8-11-04 **CONJUGAL RELATIONS** Widow

HEIGHT 5' 5" **CHILDREN** (2) Two

WEIGHT 124 **EDUCATION** 2nd Gr. Pub Sch.

BUILD Slender **RELIGION** Baptist

COMPLEXION Light Brown **HABITS** Abstainer

HAIR B & W **PREVIOUS NUMBERS**

EYES

In 1862, two inmates, Elizabeth Velora Elwell and Albert Green Jackson, established a correspondence and carried on a relationship while confined in the prison. In a letter Elwell writes, "Oh dear Albert my heart is broken for you. Do not think me flatering for I am not. I wished I could tare them slats of the gate so I could see. I will have to clean up stones to morrow." She concludes the letter by saying, "Can you tell me where I can get a we drop of gin?" Elwell was serving a one and a half year sentence at the prison for larceny. This was donated by the Capt. Andreas Sheerer family. (Courtesy of the Eastern State Penitentiary Historic Site Archives.)

80	YEARS	DATE OF BIRTH	7-16-1859	NATIVITY	Welsh Mts., Lancaster Co., Pa	SEX	Male.

NT IN U.S. YEARS | DATE AND PLACE OF FIRST PAPERS | | DATE AND PLACE OF NATURALIZATION

LEXION Med Fair EYES Blue HAIR Grey FOOT BUILD Slender.

RE 5 FT. 5-1/8 IN. WEIGHT 133 INDUSTRIAL RELATIONS Unapptrd.

PATION Cigar Maker WORKING WHEN ARRESTED No HOW LONG BEFORE, IF NOT 5 yrs.

TAL AT 16 YEARS FATHER Dead MOTHER Dead AGE ON LEAVING HOME

TIONAL: READS AND WRITES Yes SCHOOL, PUBLIC OR PAROCHIAL None YEARS PRIVATE SCHOOL YEARS COLLEGE YEARS AGE ON LEAVING HOME

S: Moderate ASSOCIATES: Ordinary RELIGION: None SMOKE: CHEW:

BUTE CRIME TO DRINK: PROFANITY: CONJUGAL RELATIONS: Single.

REN: None LIVING WITH WIFE OR HUSBAND: CASH: None DOLLARS

RTY: 1 pocketbook - 1 pr Scissors - 1 Pen Knife.

AND SCARS Tat J.B. on l.f.a. - Tat Blue dot above prev tat - Two flesh mole on upper lip - Flesh mole above lobe of ear.

HISTORY OF CRIME: Larceny of a horse and wagon.

COLOR: WHITE	COUNTY: Lancaster TERM: 182 June, 1939 19 .
CRIME Larceny and RSG	JUDGE: Schaeffer.
SENTENCE: MIN: 1 YRS. 6 MOS. MAX: 3 YRS. 0 MOS.	FINE: $ 50.00
REMARKS: Plea - Guilty.	
DATE OF SENTENCE 9-15-39 to begin 9-8-39 19 DATE RECEIVED 9-15-39 19	
NAME Joe Buzzard	ALIASES Joseph Sylvester Buzzard - Frazier - Jos. Bowers - Jos. Sylvester - John Burke - John Frazer.

EASTERN STATE PENITENTIARY, PA.
D-4243
9 15 39

NO. OF CONVICTIONS:

ADDITIONAL TIME TO BE SERVED

YEARS	MONTHS	DAYS	TIME

OD 4243 | NAME Joe Buzzard COUNTY Lancaster 3-8-41 MIN. 9-8-42 MAX.

Eastern State Penitentiary was a family affair for the Buzzard brothers of the Welsh Mountains of Pennsylvania. The notorious Buzzard Gang had five brothers serve time in the prison, Abe, Ike, Jacob, Joe, and Martin. The gang was primarily active in the late 1800s and early 1900s. Joe (pictured), the youngest of the brothers, considered himself the second best horse thief in the country; he ranked his brother Abe as the premier horse thief in the United States. This image was the gift of an anonymous donor. (Courtesy of the Eastern State Penitentiary Historic Site Archives.)

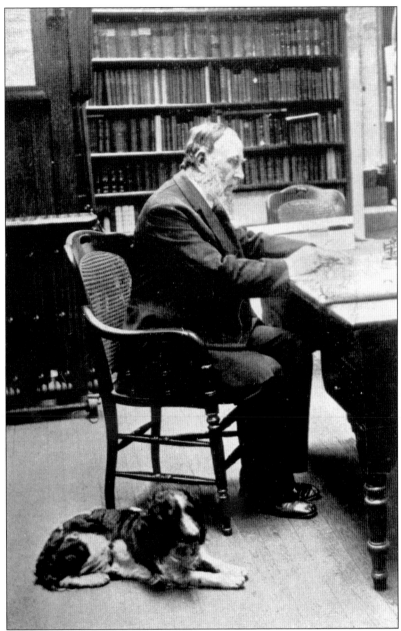

Michael Cassidy began work at the prison in 1861 as a carpenter, and by 1881, he had risen all the way to the rank of warden at Eastern State Penitentiary. Utilizing his professional background, Cassidy oversaw the construction of the cells in cell blocks 8, 9, 10, and 11, the largest cells built in the prison. Cassidy intended that inmates would build these cells, however the designs were too complicated and outside laborers were employed instead in order to maintain continuity with the design began by Haviland. Cassidy felt the quality of these cells to be superior and a reporter wrote, "Warden Cassidy believes (these cells to be) better than any room than you can get at the seashore for $25 a week." Cassidy's tenure lasted until 1900, making him the longest serving warden in the history of the prison. In this photograph, Cassidy is shown in his office with his dog. This photograph is from the book *Warden Cassidy on Prisons and Convicts* by Michael J. Cassidy

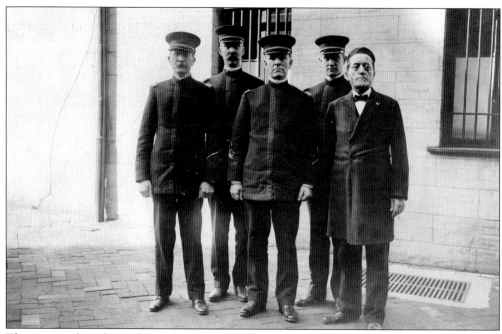

The tenure of warden Robert J. McKenty (far right) was defined by the change from a solitary to a congregate system. McKenty cared deeply about reforming inmates and believed he could have a strong effect on the men of his prison. He served as warden from 1908 to 1923. (Courtesy of Temple University Libraries, Urban Archives, Philadelphia, Pennsylvania.)

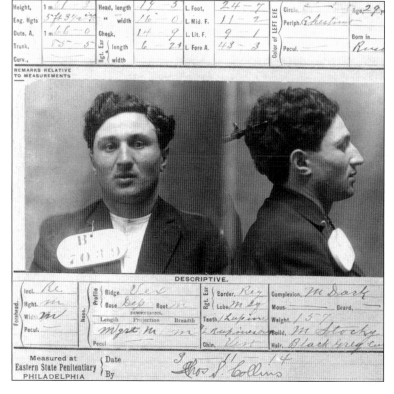

In an attempt to better understand the psychology and makeup of the criminal mind, new methods came into fashion in the early 20th century. Phrenology, the study of the shape of skulls to determine personality traits, was popular at Eastern State Penitentiary around 1900. Mug shots began to list such traits as forehead height, length and breadth of nose, and cheek width. (Courtesy of the Pennsylvania State Archives.)

During 142 years of operation, many people experienced the prison in many different ways, but very few in the same capacity as Henry Enckler. Enckler, the grandson of a deputy warden, was born at Eastern State Penitentiary in 1912 and spent several years of his childhood playing on the grounds of the prison. On his birth certificate, his place of birth is listed as "E.S.P." This photograph was donated by the Enckler family. (Courtesy of the Eastern State Penitentiary Historic Site Archives.)

Built into the facade of the penitentiary is the administrative building. Over the years, it served many different functions, one of which was residential. Until the mid-20th century, the administrative building housed the warden and his family, as well as the families of several other employees of Eastern State Penitentiary. This photograph, taken around 1912, shows the Enckler family atop the central tower of the administrative building. This photograph was donated by the Enckler family. (Courtesy of the Eastern State Penitentiary Historic Site Archives.)

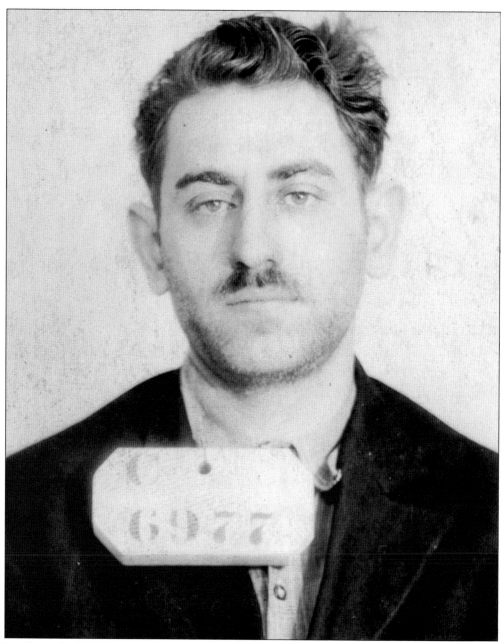

By the early 20th century, the type of criminal at Eastern State Penitentiary had changed dramatically. What was once a prison primarily for thieves, now housed murderers and rapists, in addition to many white collar criminals apprehended for embezzlement and forgery. This image was the gift of an anonymous donor. (Courtesy of the Eastern State Penitentiary Historic Site Archives.)

This list from the annual report details the crimes committed by the 1753 inmates housed in Eastern State Penitentiary in 1928. Murder tops the list. (Courtesy of the Eastern State Penitentiary Historic Site Archives.)

CRIMES

The 1753 prisoners now serving sentences in the Eastern State Penitentiary and the New Eastern State Penitentiary were convicted of the following crimes:—

	Sentenced Prior to June 1, 1927	June 1, 1927 to May 31, 1928 Received	Discharged	Remaining
Arson & Mal. Burning	19	13	9	23
Assault & Battery	0	47	19	28
Attempt to Dynamite	0	1	0	1
Bigamy	1	1	0	2
Breaking Jail	4	8	3	9
Breaking & Entering	0	19	7	12
Burglary	218	86	79	225
Conspiracy	6	3	1	8
Counterfeiting	0	1	0	1
Embezzlement	4	3	1	6
Extortion	0	3	1	2
False Pretense	4	0	3	1
Felonious Assault	84	10	18	76
Felonious Entry	128	62	76	114
Forgery	24	23	16	31
Fornication	0	1	0	1
Fraudulent Conversion	1	0	1	0
Horse Stealing	1	0	1	0
Issueing Worthless Checks	3	0	1	2
Incest	1	0	1	0
Kidnapping	1	0	0	1
Larceny	199	178	108	269
Malicious Mischief	0	1	0	1
Manslaughter	56	18	20	54
Mayhem	1	0	0	1
Murder	342	66	37	371
Obstructing R. R. Tracks	5	1	0	6
Pandering	5	4	3	6
Perjury	0	2	0	2
Pointing Revolver	1	0	1	0
Rape	132	38	30	140
Poss. of Burglar Tools	0	1	0	1
Rec. Stolen Goods	14	12	11	15
Robbery	277	116	80	313
Selling Drugs	2	0	0	2
Sodomy and Buggery	30	8	9	29
Total	1563	726	536	1753

EASTERN STATE PENITENTIARY of PENNA., Philadelphia.

PRISONER'S SIGNATURE: Henry Adams CLASSIFICATION: 11 94000 8 / 18J100 16

PRISON REG. NUMBER C 6720

COMMITTED AS HENRY ADAMS TAKEN BY DATE 1-15-3

1. Right Thumb	2. R. Index Finger	3. R. Middle Finger	4. R. Ring Finger	5. R. Little Finger
O	11	12	O	8

6. Left Thumb	7. L. Index Finger	8. L. Middle Finger	9. L. Ring Finger	10. L. Little Finger
19	8	11	O	16

ESCAPE ESCAPE ESCAPE
HENRY ADAMS, al- Henry Michael Adams, sentenced from York Co., Pa., to the Eastern State Penitentiary, Phila., Pa. No. C-6720, to 5 to 10 years, for Felonious Entry (2 Bills). DESCRIPTION: White-male; age, 29-1931; build, medium; complexion, med dark; eyes, dk.chest.; hair, dk.chestnut; stature, 5'6-5/8"; weight, 158 lbs. SCARS & MARKS: Small brown hairy mole near in border R ear. Subject was transferred to York Co Prison-6/18/35, still under the jurisdiction of the Eastern State Penitentiary. ESCAPED FROM YORK COUNTY PRISON, 7/22/35. IF LOCATED, ARREST HOLD AND WIRE AT OUR EXPENSE
HERBERT SMITH, WARDEN,
EASTERN STATE PENITENTIARY.
HS:TSC-s Issued: 9/20/35.

C 6720

After the phrenology craze died down, prison officials looked for new ways to track and catalog inmates. Henry Adams was fingerprinted when brought to Eastern State Penitentiary in 1935, an innovation which helped bring him back to prison when he escaped. This was donated by the family of Capt. Andreas Scheerer. (Courtesy of the Eastern State Penitentiary Historic Site Archives.)

Nicknamed "Hardboiled" for his rigid demeanor, Herbert Smith was one of the longest serving wardens in the history of Eastern State Penitentiary, holding the office from 1928 to 1946. Originally Smith had served as the captain of the guards under warden John Groome and was promoted to warden when the latter retired. This image was the gift of an anonymous donor. (Courtesy of the Eastern State Penitentiary Historic Site Archives.)

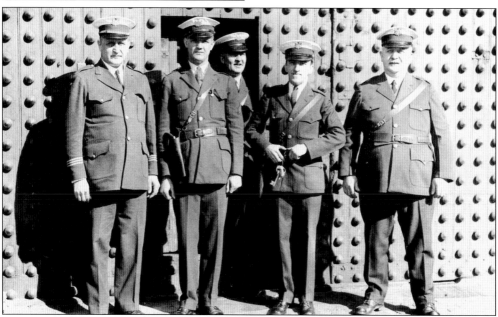

Smith and the guards had their hands full with the inmate population in the 1930s. On the eve of a 1934 riot, Smith approached the board of trustees and asked for greater authority to deal with the unruly inmates. His request was granted. The following day, Smith wasted no time in using his newly granted privileges and personally dragged the ringleaders from their cells and led them to punishment cells where the inmates were gassed before returning to their cells. This image was the gift of an anonymous donor. (Courtesy of the Eastern State Penitentiary Historic Site Archives.)

Frank Martin served as the warden of the penitentiary from 1955 to 1956 during a period of rapid turnover inside the prison. In this photograph, Martin leads several members of the Eastern State Penitentiary football team onto the field at Graterford Penitentiary. Each year, teams from the two prisons would play each other on Armistice Day. This image was the gift of an anonymous donor. (Courtesy of the Eastern State Penitentiary Historic Site Archives.)

Until the mid-20th century, firsthand inmate accounts of Eastern State Penitentiary were extremely rare, though the recollections of inmate Clarence Alexander Rae show an interesting perspective on the life of a prisoner. After kidnapping a boy from Coatesville, Pennsylvania, Rae was brought to Eastern State Penitentiary in 1916. While at the prison, Rae penned a book of poetry titled *A Tale of a Walled Town* describing his experience at the penitentiary. He writes, "To Strive, with tireless hands and an iron will/To fashion a future good from a by-gone-ill/Is not this the spirit of McKentyville?" (Courtesy of the Eastern State Penitentiary Historic Site Archives.)

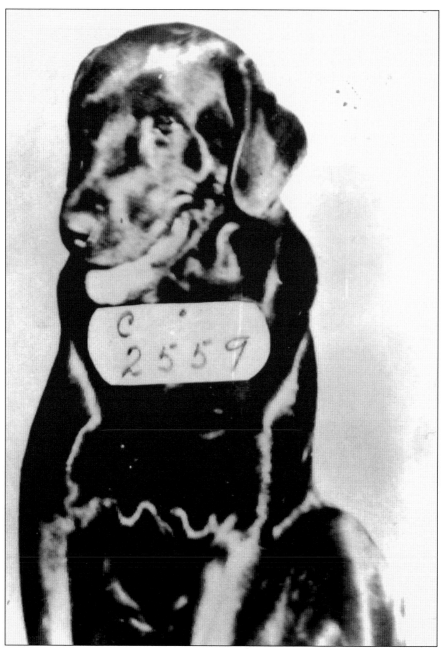

In 1924, Eastern State Penitentiary received its most unusual inmate, a black Labrador retriever named Pep. Inmate No. C2559 was allegedly sentenced to life in prison for murder. But Pep was merely following his animal instinct, as the victim in question was a house cat. Both Pep and the cat were the pets of Pennsylvania governor Gifford Pinchot. In what was most likely a publicity stunt by the governor, Pep was sentenced to a life sentence at the prison and given the name Pep in the hopes that he would bring a little joy to his fellow inmates. In actuality, Pep probably became a companion to the guards of Eastern State Penitentiary, accompanying them as they made the rounds of the jail. Pep was transferred to Graterford Penitentiary upon its completion in 1929. This image was donated by Joseph Brierly. (Courtesy of the Eastern State Penitentiary Historic Site Archives.)

Strangely enough, Pep was not the only dog at Eastern State Penitentiary. Lady, a beagle who belonged to the captain of the guards, was also at the prison for a time and posed for this picture. This photograph was taken in 1957. Inmates were sometimes allowed to keep pets in their cells. Charles Dickens, in *American Notes*, recalled an inmate that was housing a rabbit in his cell. Other pets included birds and cats. This image was donated by Howard H. Haines, captain of the guards. (Courtesy of the Eastern State Penitentiary Historic Site Archives.)

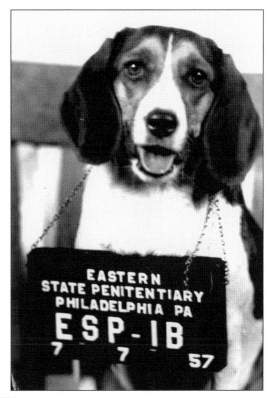

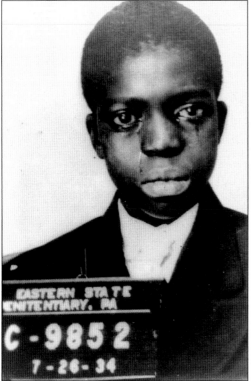

Perhaps the youngest inmate in the history of Eastern State Penitentiary, 12-year-old Wilmer Jackson was sentenced in 1934 for second-degree murder. This photograph was donated by Joseph J. Mucerino. (Courtesy of the Eastern State Penitentiary Historic Site Archives.)

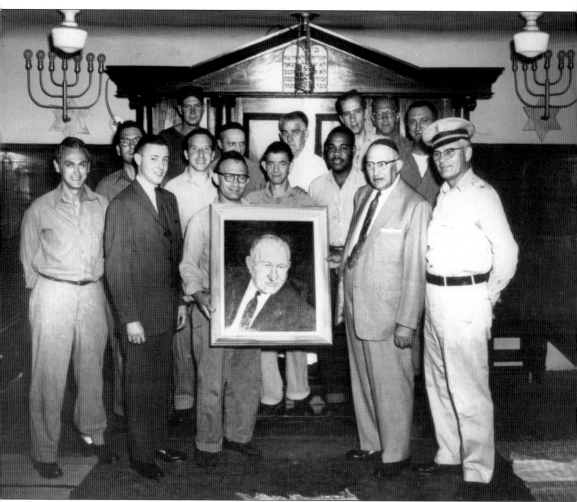

Famous Jewish strongman Joseph Paull came to Eastern State Penitentiary in 1923 to perform his feats of strength for the inmates. He was so impressed by the efforts of the Jewish inmates that he became a dedicated volunteer at Eastern State Penitentiary's synagogue until 1960. Paull donated his time to assist in services inside the prison, provided meat from the kosher butcher shop that he ran, and worked with released inmates to match them with employers. In 1959, he was honored with a portrait by the inmates that he had helped. (Courtesy of the Historical Society of Philadelphia.)

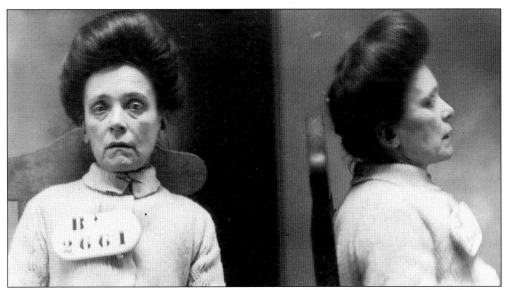

In February 1905, this woman was arrested, along with her husband, for running a bawdy house in Philadelphia. She was sentenced to three years in the penitentiary; he was to serve four years in the same facility. At the time this photograph was taken, No. B2661 was 35 years of age. Women were a regular part of the inmate population from 1831 until 1923, though they never accounted for more than a small percentage of the total prisoners at any one time. This image was donated by the family of Capt. Andreas Scheerer. (Courtesy of the Eastern State Penitentiary Historic Site Archives.)

MPLE ON	med. fair	EYES	brown		HAIR	dk. brown		FOOT	8¼
ATURE	5 FT.	IN.¼	WEIGHT	117	INDUSTRIAL RELATIONS	unapprtd.			
:CUPATION	houseworkk		WORKING WHEN ARRESTED	yes	HOW LONG BEFORE, IF NOT				
:RENTAL AT 16 YEARS	FATHER	living	MOTHER	living	AGE ON LEAVING HOME	13		YEARS	
:UCATIONAL: READS AND WRITES	native	PUBLIC SCHOOL	7 YEARS	PRIVATE SCHOOL		YEARS	AGE ON LEAVING	13	YEARS
ABITS:	moderate	ASSOCIATES:	ordinary		RELIGION:	protestant	SMOKE: no	CHEW: no	
:TRIBUTE CRIME TO DRINK:	no		PROFANITY:	no	CONJUGAL RELATIONS:	widow			
CHILDREN:	1 child	LIVING WITH WIFE OR HUSBAND:			CASH:	4	DOLLARS	13	CENTS

ROPERTY: 3 bracelets, 2 earrings, 11 spoons, lwathc & chain, 1 locket & chain, stone out, 8 rings, 3 stones out, 2 cuff buttons, 2 charms & breast pin.

MARKS AND SCARS 1 large scar of burn on r fin frt. Ridge o nose flat. Num. brown moles on face & forehead

COLOR:	white	COUNTY:	Phila.	2/6	October, 1912	19
CRIME	Murder			39 yrs. 4 mos. - 0 days.		
SENTENCE: MIN.	24 YRS. 3 MOS.	MAX.		YRS.	MONTHS	
FINE: $		REMARKS:		JUDGE:		
DATE OF SENTENCE	12-29-13	19		DATE RECEIVED	12-31-13	19
NAME	Freda H. Frost			ALIASES		

		ADDITIONAL TIME TO BE SERVED			
NO. OF CONVICTIONS:	1	YEARS	MONTHS	DAYS	TIME
NO.	NAME	COUNTY		MIN	MAX

In 1920, an all female facility was created in Lycoming County, thus ending the need to house women at Eastern State Penitentiary. This new institution, named the Muncy Industrial Home, was designed to be a training school for women aged 18–30. Freda Frost (alternately referred to as Trost in some documents) was the last woman to be regularly housed in Eastern State Penitentiary. She was serving time for the poisoning death of her husband. This image was the gift of an anonymous donor. (Courtesy of the Eastern State Penitentiary Historic Site Archives.)

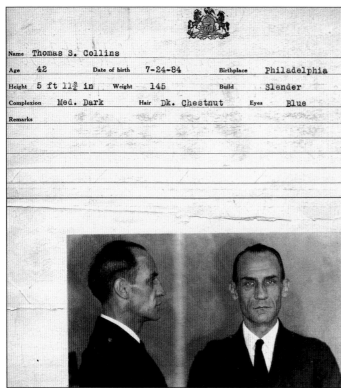

Name	Thomas S. Collins
Age	42
Date of birth	7-24-84
Birthplace	Philadelphia
Height	5 ft 11½ in
Weight	145
Build	Slender
Complexion	Med. Dark
Hair	Dk. Chestnut
Eyes	Blue
Remarks	

Even employees were fingerprinted and had their photographs taken by the penitentiary. Officer Tom Collins began working at Eastern State Penitentiary in 1926. Many of the officers lived in close proximity to the prison and would be called to work in the event of an emergency, such as an escape or riot. This image was donated by Emily Rafter, Mary B. Marden, James J. Farley, Kate Farley, Bernard C. Farley, and John P. Farley. (Courtesy of the Eastern State Penitentiary Historic Site Archives.)

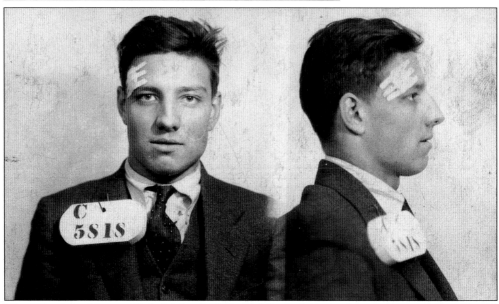

The "Toughest Man in Philadelphia," William "Blackie" Zupkoski was sentenced to 70–140 years for over 40 counts of armed robbery. Always a troublemaker, the rabble rousing did not end for Zupkoski once he entered prison. In 1929, he stabbed another inmate, Lewis Barrish, to death outside of cell block 10. This image was donated by Emily Rafter, Mary B. Marden, James J. Farley, Kate Farley, Bernard C. Farley, and John P. Farley. (Courtesy of the Eastern State Penitentiary Historic Site Archives.)

The notorious Chicago gangster known as Alphonse "Scarface" Capone arrived at Eastern State Penitentiary in 1929, serving eight months for carrying a concealed deadly weapon. It has long been rumored that Capone arranged his trip to prison to avoid the repercussions of the St. Valentine's Day Massacre in Chicago, an event that saw Capone plan the deaths of several rival bosses. While at Eastern State Penitentiary, Capone purchased new uniforms for the prison's baseball team as a gesture of goodwill towards the other inmates. This mug shot photograph lists the occupation of Capone as a cutter of paper and leather. It was updated following his death in 1947. (Courtesy of the Philadelphia Police Records Division.)

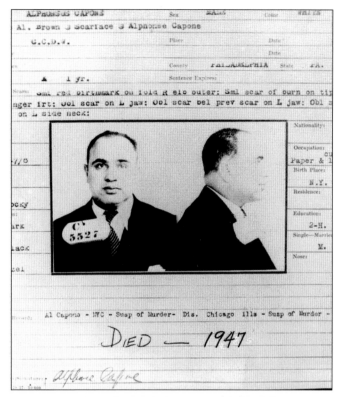

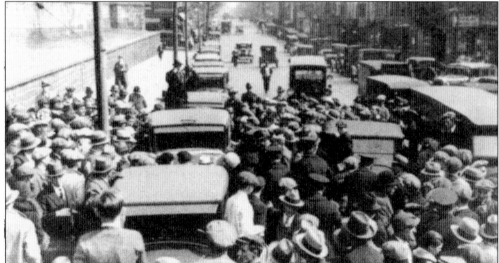

Several hundred onlookers gathered outside Eastern State Penitentiary on the morning of March 17, 1930, in the hopes of catching a glimpse of one of the world's most famous criminals. Capone was to be released that day, and his celebrity status attracted quite an audience. The crowd waited for several hours with no sign of Capone. Fearing that some of his enemies may be lying in wait, Capone had struck a secret deal with Eastern State Penitentiary warden Herbert Smith that allowed him to sneak out of the prison several hours earlier than was expected, transfer to Graterford, and be released from that institution at the appointed time. (Courtesy of the Philadelphia Police Records Division.)

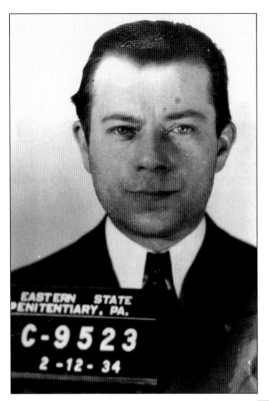

William Francis Sutton was a Brooklyn native who went on to be one of the most infamous bank robbers in the history of the United States. Sutton was brought to Eastern State Penitentiary in 1934 after being arrested for the robbery of the Corn Exchange bank at Sixtieth and Market Streets. Sutton was known as the "Gentleman Bandit" more for his charming demeanor during a robbery than for his mediocre looks. He was also known as the "Actor" because he frequently disguised himself as a delivery man or police officer during robberies. This image was donated by ESP's friends of CAMA-PA. (Courtesy of the Eastern State Penitentiary Historic Site Archives.)

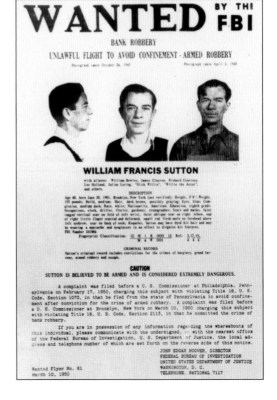

Though denied by Sutton, he was once quoted as saying, when asked why he robbed banks, "because that's where the money is." During his lifetime, he penned two autobiographies, *That's Where the Money Was* and *I, Willie Sutton*. Sutton died a free man in Florida in 1980, having gotten most of his convictions overturned on technicalities.

Frederick Tenuto was a Philadelphia hit man for the mob who wound up serving time at Eastern State Penitentiary in the 1930s and 1940s. Known as the "Angel of Death" for his line of work, Tenuto also wound up with a reputation as an escape artist and as a hard man to find. On April 3, 1945, he was 1 of 12 inmates involved in the tunnel escape from cell block seven. He was recaptured almost two months later in Brooklyn with fellow escapee "Botchie" Van Sant, making them the last two inmates from the tunnel escape to be brought back to Eastern State Penitentiary. This image was donated by the Capt. Andreas Sheerer family. (Courtesy of the Eastern State Penitentiary Historic Site Archives.)

In 1946, Tenuto, along with Sutton and Klinedinst, was transferred to Philadelphia's Holmesburg Prison, which no one had ever escaped from. The following year, Sutton and Tenuto escaped with several other inmates. Tenuto was never recaptured. Sutton was at large for several years before he was recognized and turned in by Arnold Schuster, a barber from Brooklyn. After appearing on national television to discuss Sutton, Schuster was shot to death two blocks from his home. His shadowy assassin was never caught, though Tenuto has long been rumored to be the triggerman. This photograph was donated by ESP's friends of CAMA-PA. (Courtesy of the Eastern State Penitentiary Historic Site Archives.)

Walter Tees began his career at Eastern State Penitentiary as an officer and was one of the guards that recaptured William Sutton during the 1945 tunnel escape. Tees served as warden from 1953 to 1955. This photograph was donated by the Biedermann family. (Courtesy of the Eastern State Penitentiary Historic Site Archives.)

In the mid-1950s, inmate Lester Smith painted murals in the Catholic chaplain's office between cell blocks one and nine. The murals depicted scenes of a religious nature that would hopefully inspire the other inmates. Smith was serving one to five years for armed robbery and had no use for religion before his time at Eastern State Penitentiary. While incarcerated, he began to see things in a different light. "I used to mock ministers and priests," he told a reporter from the *Philadelphia Inquirer*, "Then one day I found I could not go it alone." Once released from Eastern State Penitentiary, Smith was never rearrested. This image was a gift from the Lester Smith family. (Courtesy of the Eastern State Penitentiary Historic Site Archives.)

Mack's last day is seen here and there are smiles all around; in the image, a group of inmates meet in the tailor shop to celebrate the release of Mack, the inmate in the center. With his new suit, courtesy of the prison, he prepares to reenter into society. Prison was often a harsh and unforgiving environment, so it was important to remember the good times. This photograph, donated by Anthony Jacobs, was taken in 1969, shortly before Eastern State Penitentiary was closed. (Courtesy of the Eastern State Penitentiary Historic Site Archives.)

Three

ALL WORK
AND SOME PLAY

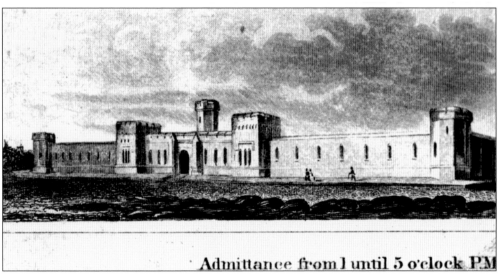

Admittance from 1 until 5 o'clock PM

From the time that it opened in 1829, Eastern State Penitentiary was a world famous building, attracting visitors from several continents. Despite the solitary confinement system that permitted no visitors to the inmates, tourists were allowed to sightsee at the state-of-the-art facility. This is a ticket issued to 19th-century visitors to the penitentiary. For a time in the 1800s, Eastern State Penitentiary was the largest tourist attraction in the Philadelphia area. (Courtesy of The Library Company of Philadelphia.)

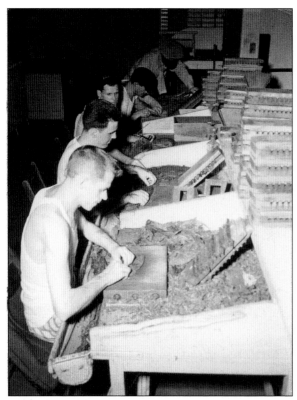

In 1929, the administration of Eastern State Penitentiary created a 30-minute-long silent film to honor the 100th anniversary of the institution. With the opening of Graterford Penitentiary that same year, there was talk throughout the state that Eastern State Penitentiary would be closed. This black and white film was created to showcase the value of the prison and prove that it was still a viable institution for reform. The film focuses on the productive work of the inmates, highlighting the various workshops and industries powered by inmate labor. This image was donated by the family of Capt. Andreas Scheerer. (Courtesy of the Eastern State Penitentiary Historic Site Archives.)

When Eastern State Penitentiary first opened in 1829, the Bible was the only book that the inmates were allowed to have. Over the years, this policy changed and a large library was created for use by the inmates. Containing over 10,000 volumes, the library was a repository of information for the inmate that wished to better himself through literature and learning. This photograph shows the original library that was built above the prison's central command hub. In later years, the library was moved to the yards of cell block one to be closer to the newly constructed school buildings. This image was from the 1925 annual report.

league's three umpires, have shown their capability in the early season games. We are assured of continued good officiating in future games.

David J. Brinkly, official scorekeeper, is always on the scene doing a first-class job.

CUBAN LEAGUE
Official Standings

Team	Won	Lost	Pct.	GB
Rams	5	2	.724	—
Dodgers	5	3	.625	½
Pirates	5	3	.625	½
Yankees	3	4	.429	2
Falcons	3	4	.429	2
Giants	1	6	.143	4

CUBAN LEAGUE
TOP TEN HITTERS

Player	Team	G.	AB	H	Ave.
Danny	Giants	4	7	5	.714
Connors	Giants	4	10	5	.500
Heads	Giants	4	12	5	.417
Turk	Rams	7	17	7	.412
Barney	Yankees	7	22	9	.409
Levi	Pirates	7	20	8	.400
Curley	Yankees	7	17	6	.353
Hallowell	Falcons	4	12	4	.333
Norman	Pirates	7	22	7	.318
O'Neill	Yankees	6	16	5	.312

Of all the sports played at Eastern State Penitentiary, the most popular was probably baseball. There were several different leagues, each with a variety of teams that played a 70-game schedule. Some of them were the Nine, the Printers, and the Falcons. By the mid-20th century, a fence had been added to the prison's north wall, which also served as left field, in order to cut down on the number of home runs that were becoming souvenirs for the neighborhood. This image was from the summer 1959 issue of *Eastern Echo*.

In one year in the 1940s, over 4,500 baseballs were hit over the prison's north wall, which also doubled as left field. These baseballs became souvenirs for people in the neighborhood, though some also found their way back into the facility. Baseballs filled with drugs or razors were sometimes thrown back over the wall into the field, creating a way to smuggle contraband into the prison. Another occasion saw several sticks of dynamite come over the wall. An inmate brought the explosives back to his cell, but the lack of a detonator prevented their use. This image was donated by Jack Flynn. (Courtesy of the Eastern State Penitentiary Historic Site Archives.)

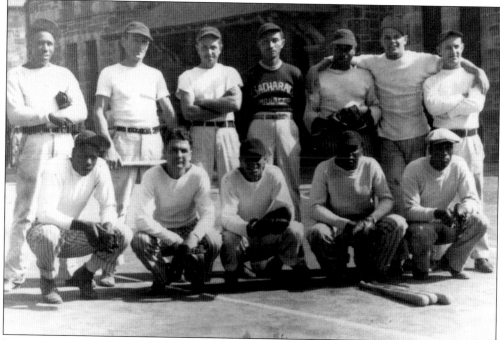

In 1917, Sam "Red" Crane, shortstop for the Philadelphia Athletics, was brought to Eastern State Penitentiary after being convicted of murdering his girlfriend. He quickly became the baseball team's star player. (Courtesy of Temple University Libraries, Urban Archives, Philadelphia, Pennsylvania.)

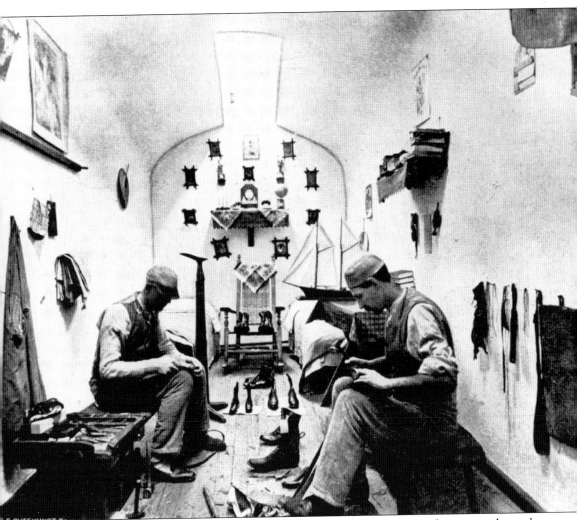

This is a typical two-inmate cell at Eastern State Penitentiary. After 1913, the inmates housed at Eastern State Penitentiary spent less time in their cells and more time outside working at jobs and participating in sports and other leisure activities. As a result of this, the cells became more a place for the inmates to sleep and less of the home that they were in the earlier days. Each inmate was given a bed, a footlocker, a small table/nightstand and were allowed to personalize the space with some decorations. The cells were also equipped with radio jacks in the wall, which gave the inmates access to four separate radio stations that were all broadcast from a room within cell block seven. This image is from the book *Warden Cassidy on Prisons and Convicts* by Michael J. Cassidy.

In 1920 or 1921, warden Robert McKenty commissioned the construction of a plaque to honor the inmates from Eastern State Penitentiary that served in the military for World War I. These inmates were not conscripted into the military but rather were parolees or had been released and wished to serve their country. However, as felons none of them were eligible for military service. McKenty argued on their behalf, espousing the virtues of the rehabilitation at Eastern State Penitentiary, and the men were allowed to serve. The plaque lists 121 inmates, however there are no names to identify them, merely the numbers that they wore as inmates. This image was a gift from the McKenty family. (Courtesy of the Eastern State Penitentiary Historic Site Archives.)

In 1923, an article in the *Philadelphia Evening Bulletin* reported corruption and drug dealing running rampant within the walls of the penitentiary. The primary culprits seemed to be a group of inmates known as the Four Horsemen. These four inmates were originally chosen to be part of a committee that voiced inmate concerns to the administration, but an abuse of granted privileges resulted in an increase of drugs and violence in the prison. After the publication of the report, the Four Horsemen were transferred to Western State Penitentiary. This photograph was donated by the family of Capt. Andreas Scheerer. (Courtesy of the Eastern State Penitentiary Historic Site Archives.)

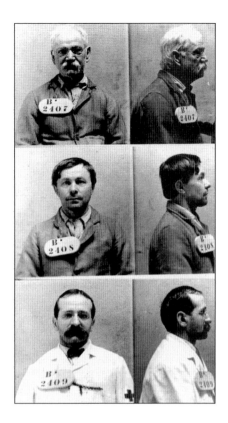

THE UMPIRE

DEVOTED TO THE INTERESTS OF RECREATION AND GOODFELLOWSHIP

Vol. 2 No 2. **Wednesday March 26, 1913** **Priceless**

Baseball

The days have come, for hits and runs,
For aches and sores, for wordy wars,
 In Baseball.

The clubs in line, all show up fine,
There is no sign, of losing time
 At Baseball.

The Ninth looks fit, and say they're It,
They field and hit, but wait a bit
 Its Baseball.

The Stocking Shed, are far from dead,
They go ahead, and talk in bed
 Of Baseball.

And in the Band, the boys play grand,
Have they the sand, to make a stand,
 At Baseball?

The Plasterer team they always seem,
To have the steam, and are real keen,
 For Baseball.

The Library, on the gal-ler-y
Have signed a plea, the flag to see,
 That's Baseball.

The Cubs look wise, and wink their eyes,
And for their size, they may surprise,
 At Baseball.

Now watch and wait, its near the date
To pass the "gate", and see the plate.
 And Baseball.

If the team you pick, don't get their lick
Please don't get sick, or raise a kick
 It's Baseball.
 —By B 6388

Phillies Won in Ninth.

Durham, N. C.

The Phillies won out by a hair over the Durham club of the Carolina League here today. In the 9th inning, with the score 4 to 3 in favor of Durham, things looked bad for the Phillies. Magee, first up, hit a long fly to left field. Kelly booted Miller's grounder, and that started things going. Dolan sacrificed him to second, and Dooin selected himself to bat for Dodge and slammed out a two bagger, which put across the tying run, and then LaLonge ordered the same thing and Dooin scored on his two bagger.

"Wild Bill" Donovan, formerly of Detroit, and now manager of Providence of the International League, which is here training, umpired the game. Score 4 to 3.

BOOKS WORTH READING.

"LIFE IS A GLORIOUS THING."

If you wish to be lifted out of the cares of to-day, read one of the following books, which are to be found in the Library:—

For those of a historical turn of mind,—The History of Babylonia and Assyria, will be found interesting. It tells about The Towers of Babel, which is still standing. Do you realise that 4000 years after this most wonderful of all towers that was built by the Ancients, (according to the Book of Genesis about 2400 B. C.,) its seven stages still rise high above the plains near the site of Babylon:

For those who care for fiction, "The Garden Of Allah", is a most remarkable and interesting story. The story is of a monk who breaks his oath, and flees from the monastery, and later on falls in love with a beautiful young woman. The story is full of romance and adventure, and gives a vivid description of life on the desert with caravans of camels and natives.

To those who have never read Charles Dickens work, I would advise any one of the following book's:—

David Copperfield,—Little Dorrit, Pickwick Papers,—Oliver Twist, and The Lamplighters. Charles Dickens is the greatest master of story-telling the world ever knew. His keen humor, his command of pathos and perfection of character. His writings are fascinating, and appeal to both old and young. We breathlessly follow the fortunes of David Copperfield, laugh at the adventures of Mr. Pickwick; and shed a tear over Little Nell.

"Ben-Hur," is another most delightful book, from the opening of the volume to the very close, the readers interest will be kept at the highest pitch. Its real basis is a description of the life of the Jews and Roman sat the beginning of the christian era, and this is both forcible and brilliant. We are carried through a surpassing variety of scenes; we witness a sea-fight, a chariot race, the internal economy of a Roman galley, domestic interiors at Antioch, at Jerusalem, and among the tribes of the desert; palaces,

prisons, the haunts of dissipated Roman Youths. There is plenty of exciting incidents.

"Blennerhasset", is a most remarkable and interesting story,—it is a Romance, full of life, and founded upon Events in American History.

"Miss Petticoats;" this is a story of modern life, and is full of interest and brightness, and so full of action that the incidents fairly step on each others heels.

"Quincy Adams Sawyer and Mason Corner Folks"—This is the best New England story ever written.—A simple love tale of country life with a wealth of New England characters, scenes and incidents.

BASE BALL IS BRED.

WHAT is the exhilarating intoxicant with which the Southern atmosphere seems pregnant in the producing of great ball players? Ty Cobb, Tris Speaker, Joe Jackson, and Claude Cooper, the recent great find of the New York Giants, all hail from below the Mason and Dixon line, and each and every one of them is a star which absolutely scintillates in the baseball firmament. Are climatic condition responsible for better and faster players in the South than in the North? Or what is it? The best explanation in relation to this situation was made to me by Frank Newhouse, now umpiring on the Pacific coast. Newhouse said:

"You know is gets so awful hot in Texas, and elsewhere in the South, that a sort of mist or heat cloud arises from the ground. The man who can bat well in those leagues, can bat anywhere on earth, for it takes a better eye to hit the ball accurately in the South, than it does in the North. That's why men like Cobb, Speaker and others, prove such sensations when in the big leagues."

Whether this is the correct solution or not, we leave to those who read to decide. Certain it is that the explanation carries some merit with it, and who knows but this umpire has correctly sized up the situation? All the great stars coming from the leagues in the South, proved themselves fine ball players in the American and National leagues. True, they are not all Ty Cobbs, Speakers or Jacksons, but they are good enough to hold their own anywhere.—*Exchange.*

The earliest inmate publication at the prison was a periodical called the *Umpire*. The *Umpire* focused primarily on sporting events at the prison, though other issues were tackled as well.

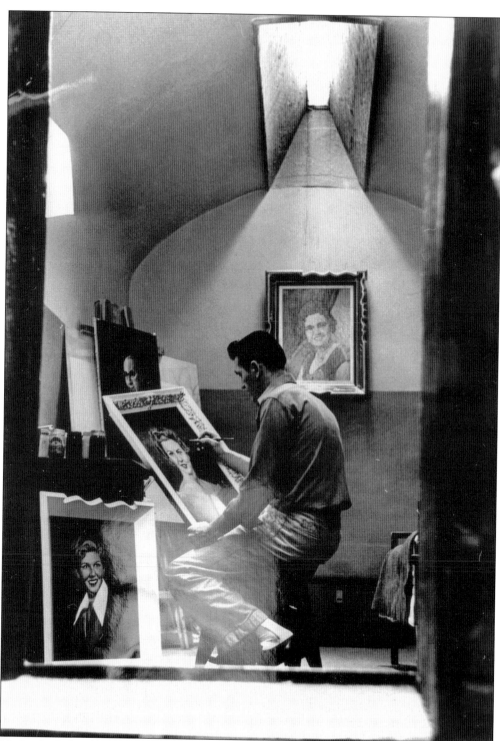

Under the light of his skylight, an inmate paints a portrait in his cell. Working from memory or photographs, the unidentified man recalls his life before prison through his canvas and paints. (Courtesy of Temple University Libraries, Urban Archives, Philadelphia, Pennsylvania.)

On display in the central hub are various model boats made by the inmates at the penitentiary. There was a boat-making shop inside of the prison, and the ships were often sold on the outside to generate revenue for the prison. Bookbinder's restaurant in Philadelphia was known to display these works in their front windows. This image was donated by the family of Capt. Andreas Scheerer. (Courtesy of the Eastern State Penitentiary Historic Site Archives.)

Jake Pensendorfer served 25 years at Eastern State Penitentiary for murder. While at Eastern, he earned $50,000 from creating woodcarvings. When he was pardoned, Pensendorfer used the money to open a woodworking shop that employed only ex-convicts in order to give them a new start outside the walls. (Courtesy of the Eastern State Penitentiary Historic Site Archives.)

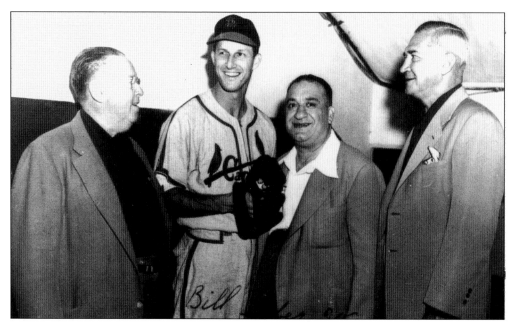

Eastern State Penitentiary was no stranger to famous visitors. New York Yankees slugger Babe Ruth paid a visit to the inmates in 1928, taking time to hit some fly balls with the men. This photograph, donated by Joseph J. Mucerino, shows a member of the St. Louis Cardinals meeting with prison officials. (Courtesy of the Eastern State Penitentiary Historic Site Archives.)

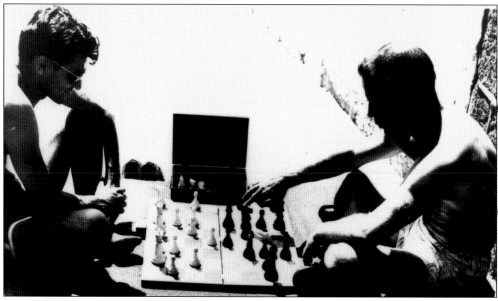

Of all the sports teams at the prison that competed against outside competition none were as successful as the chess team. A member of the Philadelphia League, the chess team competed against many local universities and businesses with a great deal of success. In 1962, a banquet was held in the prison's chapel space to honor the team. Former inmate Jesse Digulelmo reflects the attitude of the team, "The chess playing. We played chess every day. Every day, every minute that we got." This image was donated by Joseph J. Mucerino. (Courtesy of the Eastern State Penitentiary Historic Site Archives.)

WEIGHTLIFTERS

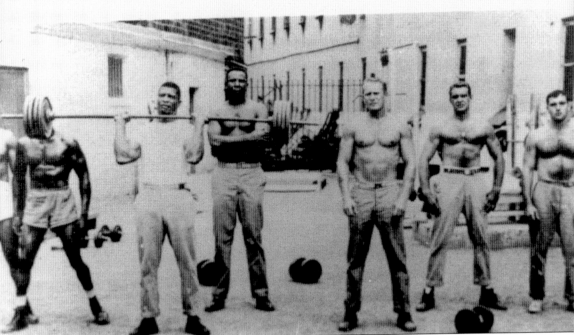

In the 20th century, a weight yard for the inmates was constructed between cell blocks 6 and 12. A popular activity, some inmates spent all two hours of yard out pumping iron. In 1962, a weight lifting contest was held in the prison against a team from the local branch of the YMCA. Instead of playing sports with the other inmates, these prisoners chose to work on their physiques. This photograph chronicles their hard work, though one inmate's face has been unfortunately obscured by another's weights. This image was from the fall 1966 issue of *Eastern Echo*.

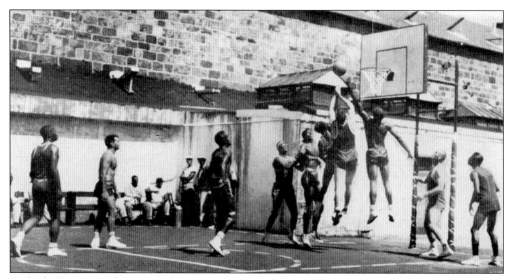

Basketball was another sport that was taken very seriously by the participants. In the 1960s, Eastern State Penitentiary had two separate leagues, the One Block Basketball Association (O.B.B.A.) and the Eastern Basketball League (E.B.L.). Each league consisted of four teams, such as the Sure Pops, the Warriors, and the Vagabonds. The E.B.L. contained the higher caliber of player and would often host teams from the outside, though they were not very successful. The *Eastern Echo* recalls that outside teams were always cheered greatly, thus nullifying whatever home field advantage the boys from Eastern State Penitentiary may have possessed. This image was from the fall 1961 issue of *Eastern Echo*.

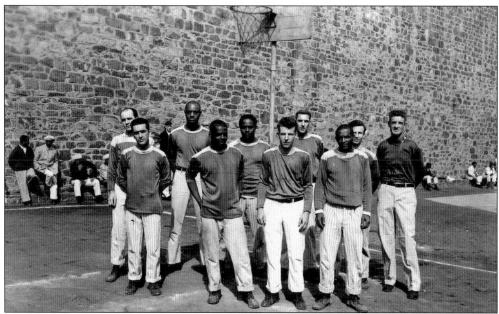

In 1962, the O.B.B.A. put together an all-star team to play against some outside competition. The Thompson Terrors, a team of teenagers, were the first to step up to the challenge. They demolished the inmate team by a score of 95-38. The O.B.B.A. all-stars blamed the loss on being undermanned; before the start of the game, several star players were called off for visitation and were unable to play in the contest. (Courtesy of the Eastern State Penitentiary Historic Site Archives.)

Beginning in 1956, Eastern State Penitentiary started publication of the *Eastern Echo*, an inmate-produced magazine focused on material pertaining to the life of men held in the prison. Printed in the prison's print shop between cell blocks 1 and 10, the *Eastern Echo* was a venue for inmates to express their views, and they often did so in a very professional, critical manner. The quality of the publication attracted some professionals from the outside, including renowned sociology professor Negley Teeters, who published a version of his "On Public Institutions" in the magazine. Aside from scholarly works, the *Eastern Echo* also ran stories about the various sports leagues at the prison and kept inmates informed about events happening around the world.

Each issue of *The Eastern Echo* began with an address from the warden dealing with a current topic relevant to the inmates. It also noted on the inside cover that inmates opinions would be censored if they were too provocative or against the prison's regular policies. Subscriptions to the *Eastern Echo* were available to readers outside the walls for $1 a year.

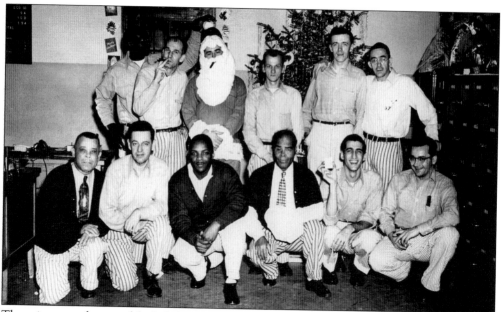

The prison was decorated for holidays and special meals, and privileges were granted to inmates who had demonstrated good behavior and responsibility. Holidays were also an opportunity for guards to show a more personal side to the inmates. Former inmate Jesse Diguglelmo recalled, "Sloan was my guard on my block. He was, like my guardian. But he was the type of man, he had a little bit of heart. Christmas, his wife made him take down all of her Christmas decorations and take them in to us so we would have a Christmas tree." This image was donated by the Biedermann family. (Courtesy of the Eastern State Penitentiary Historic Site Archives.)

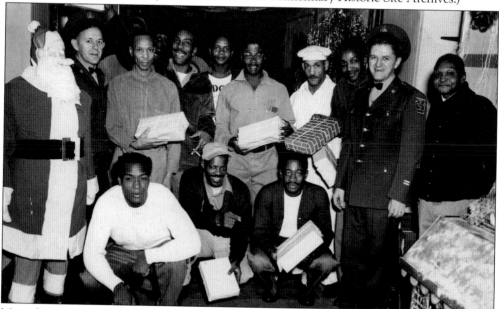

Many former inmates have recalled Eastern State Penitentiary as a humane and decent prison by the latter part of the 20th century. Holiday celebrations, such as this Christmas photograph, contributed to the good will of the inmates. This image was donated by Ray Bednarek. (Courtesy of the Eastern State Penitentiary Historic Site Archives.)

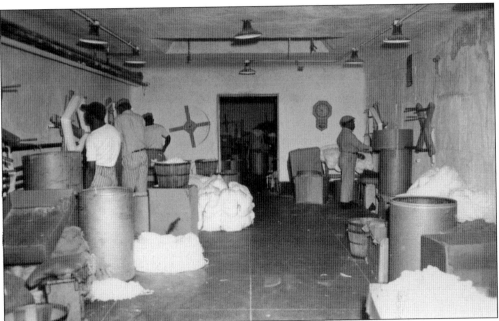

During Eastern State Penitentiary's 142 years of operation, the typical labor performed by the inmates changed dramatically. In the early days of the prison, all of the inmates worked alone in their cells; cobbling of shoes and caning of furniture were among the most common jobs. As the prison changed, so did the work available to the prisoners. By the early 1900s, inmate labor was mass-producing goods that were sold outside of the prison, as well as distributed among other facilities in the state.

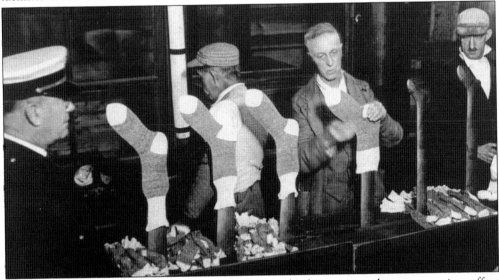

Due to the Great Depression and the newfound strength of unions, new laws were put into effect in the early 1930s that greatly limited the type of industry that the prisoners could perform. A virtually non-existent wage for the inmates allowed them to undercut most work on the outside; a 1934 report stated that inmates were being paid 10¢ a day. In this photograph, older inmates help sort out recently manufactured socks, under the watchful eyes of a guard. (Courtesy of the Pennsylvania State Archives.)

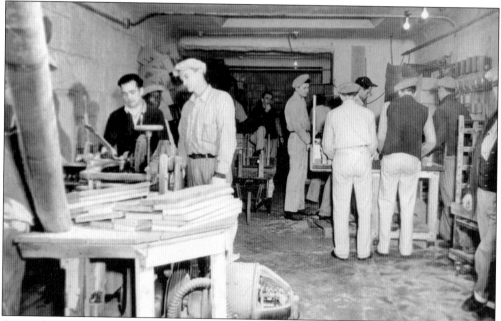

Once the prison became congregate, former exercise yards were converted into crowded workshops. In this photograph, a group of inmates casually pass the day inside a wood shop located behind one of the prison's original cell blocks. (Courtesy of Temple University Libraries, Urban Archives, Philadelphia, Pennsylvania.)

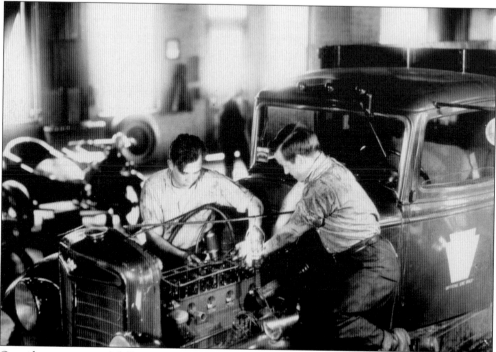

Over the years, several different garages were built adjacent to cell block seven. Originally a stable, by the 1920s this space was an auto mechanic workshop and housed a three-ton truck used by the prison. (Courtesy of Temple University Libraries, Urban Archives, Philadelphia, Pennsylvania.)

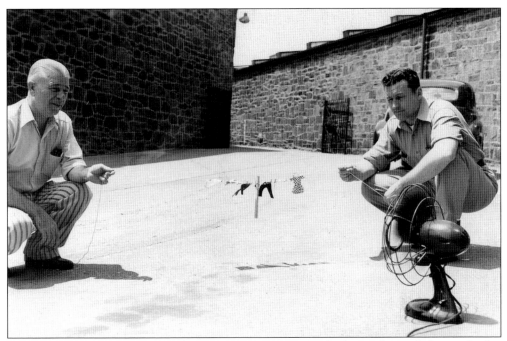

The life of an inmate could often be monotonous, sometimes leading to bizarre behavior. In this photograph, donated by the family of Capt. Andreas Scheerer, two older inmates constructed a makeshift clothesline in order to dry some miniature clothing. The reason for this is unknown. (Courtesy of the Eastern State Penitentiary Historic Site Archives.)

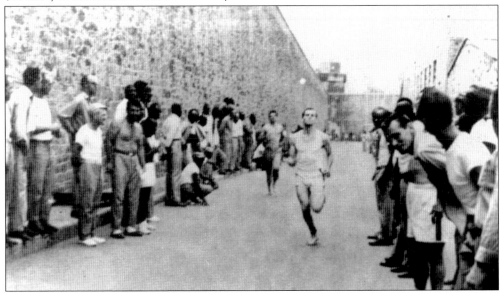

With the change to a congregate system in 1913, it became necessary to create more recreational space for the inmates during yard out. The long straight driveways along the walls, which were previously off limits to prisoners, were converted to exercise space where the inmates would have races with one another. Raised curbs were put along the base of the wall to create bocce courts, which were popular with many older inmates. This image was from the fall 1966 issue of *Eastern Echo*.

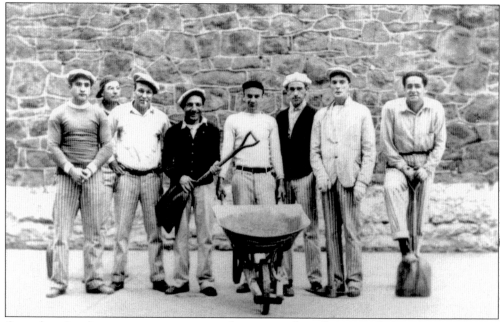

Once the prison became congregate inmates began to work in all areas, including the construction of new buildings and the maintenance of old ones. Occasionally more trusted inmates would be allowed to leave the prison grounds. Inmates from Eastern State Penitentiary were a large part of the work crew that constructed Graterford Penitentiary. This image was donated by David DiGuglielmo. (Courtesy of the Eastern State Penitentiary Historic Site Archives.)

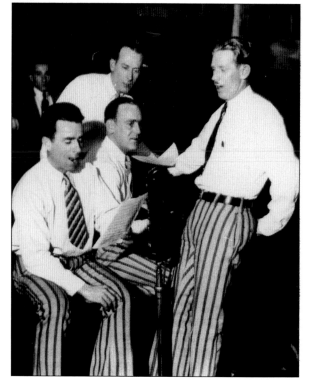

Music was also an important part of inmate life. A band practice space was set up in the room above the central rotunda for the inmates, and the *Eastern Echo* ran a regular feature instructing inmates on how to be better musicians. An inmate singing group was also popular, and their performances aired on local and national radio. (Courtesy of Temple University Libraries, Urban Archives, Philadelphia, Pennsylvania.)

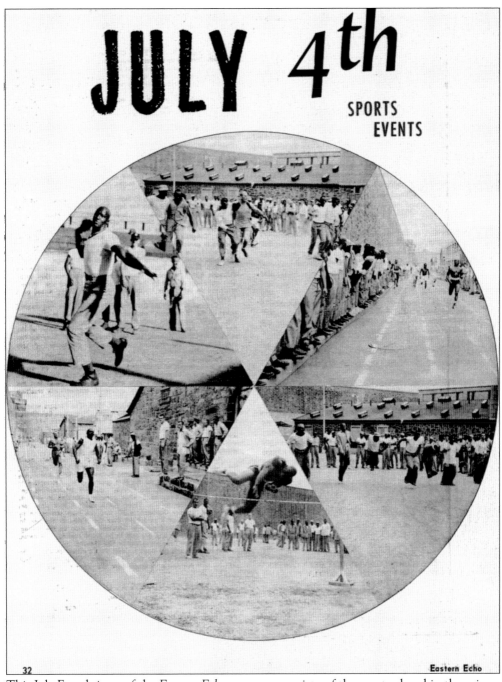

JULY 4th

SPORTS EVENTS

Eastern Echo

This July Fourth issue of the *Eastern Echo* presents a variety of the sports played in the prison. In addition to track and field events such as races and the shot put, inmates are also shown partaking in three-legged races and a potato sack race. By the time of this issue of the *Eastern Echo* (1965), Eastern State Penitentiary was a neglected prison in the Pennsylvania system, and the funding for recreation was not very generous.

One of the busier workshops in the penitentiary was the typewriter repair shop. In 1961, the shop was created and staffed by a single inmate worker. By the following year, 20 inmates were employed, and a senior citizen from the community was instructing the inmates in the trade. The trade industries in the prison were designed to provide inmates with job skills that could benefit them upon release and hopefully keep them from returning to a life of crime. This photograph was donated by the family of Capt. Andreas Scheerer. (Courtesy of the Eastern State Penitentiary Historic Site Archives.)

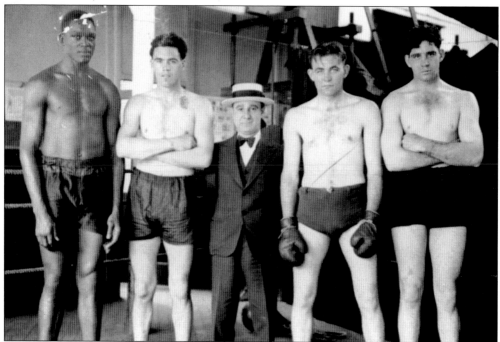

In 1923, boxing matches were instituted as another form of recreation for the inmates. Matches would only occur between inmates of the same weight class. (Courtesy of Temple University Libraries, Urban Archives, Philadelphia, Pennsylvania.)

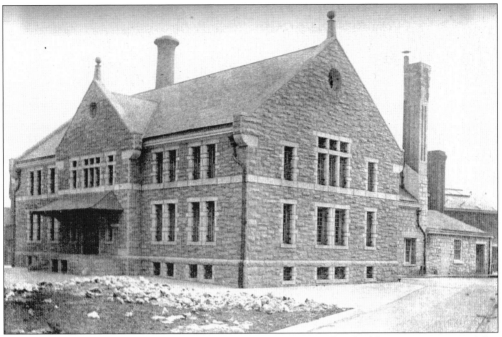

A commissary on the second floor of the kitchen was set up and staffed by inmates. Parts of this building date from the earliest days of the prison when it was used as a pump house. This image was from the 1920 annual report.

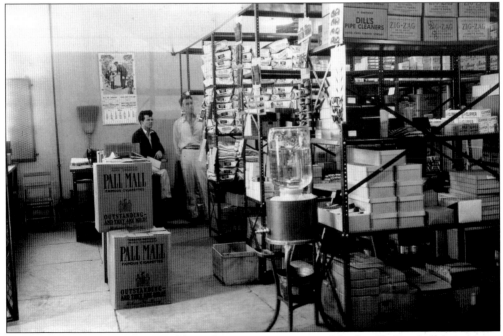

At the commissary, inmates could purchase various items and foodstuffs. Baseballs, cigarettes, and candy were all available. Cash never changed hands at the commissary; money was deducted from accounts that all of the inmates used for purchases. This image was donated by the family of Capt. Andreas Scheerer. (Courtesy of the Eastern State Penitentiary Historic Site Archives.)

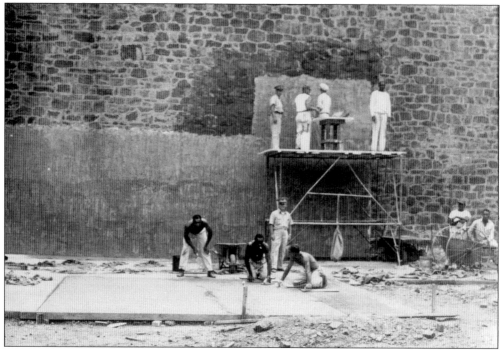

Inmates prepare one of the prison's perimeter walls for use as a handball court in this photograph, donated by the family of Capt. Andreas Scheerer. With limited recreational space, it was important that all available space was used efficiently. (Courtesy of the Eastern State Penitentiary Historic Site Archives.)

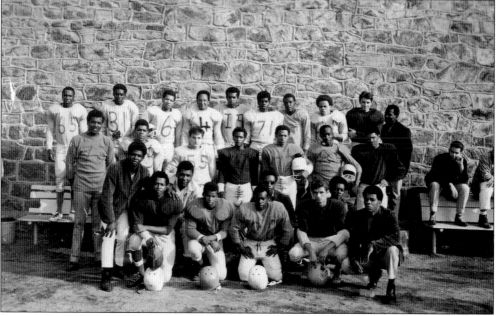

Even without a proper field to play on, football was immensely popular among the inmates. In this photograph, the team poses against the prison's north wall. This photograph was donated by Anthony Jacobs. (Courtesy of the Eastern State Penitentiary Historic Site Archives.)

Four

ESCAPES AND RIOTS

The first inmate to breach the security of these walls and escape from the penitentiary was a man named William Hamilton. In 1831, Hamilton was arrested for stealing pigs and sentenced to several years in the penitentiary. Warden Samuel R. Wood employed Hamilton as his personal waiter, despite it being against the rules of solitary confinement. In 1832, Hamilton took advantage of his job and escaped from the warden's residence in the front administrative building when he was left unattended. Several weeks later, he was recaptured when he was once again caught stealing pigs. Hamilton remained at the penitentiary to serve the remainder of his sentence. In 1837, he again escaped again. This photograph was a gift from Jack Flynn. (Courtesy of the Eastern State Penitentiary Historic Site Archives.)

In 1923, Leo Callahan left Eastern State Penitentiary and entered into his own unique place in the prison's history. Callahan arrived at Eastern State Penitentiary in 1920 serving a sentence for assault and battery with intent to kill, though he did not plan on staying long enough to complete his entire sentence. In July 1923, Callahan and five other inmates escaped by going over the prison's east wall using a homemade 30-foot ladder. After overpowering one guard and scaling the wall, the inmates found themselves on Corinthian Street. They promptly hijacked an idling car and sped off into nearby Fairmount Park. Within six months, four of the escaped men had been recaptured, one of whom was found in Hawaii. Callahan has never been found, making him the only man to ever escape from the prison and not be recaptured. This was donated by the family of Capt. Andreas Scheerer. (Courtesy of the Eastern State Penitentiary Historic Site Archives.)

A 30-foot wall is certainly an obstacle to freedom for an inmate. George Brown, a carpenter turned inmate, was able to design a 30-foot ladder that broke apart into six, five-foot segments. When assembled, it was large enough to go over the wall, but apart it could be easily hidden inside the inmates cell. Brown, Leo Callahan, and four others used the ladder to escape from the penitentiary in 1923. This image was donated by Emily Rafter, Mary B. Marden, James J. Farley, Kate Farley, Bernard C. Farley, and John P. Farley. (Courtesy of the Eastern State Penitentiary Historic Site Archives.)

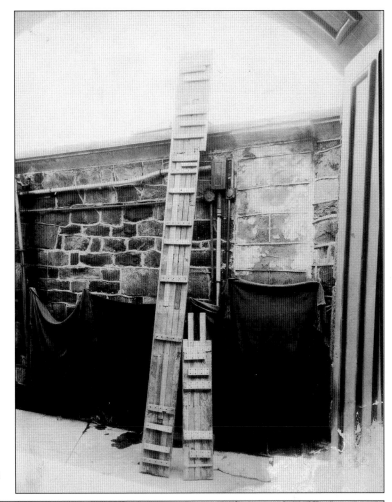

"I know where you can find a shank; it's in 39 cell on six gallery. In back of the desk draw." This note was found inside of the prison and confiscated by one of the guards. This was donated by the family of Capt. Andreas Scheerer. (Courtesy of the Eastern State Penitentiary Historic Site Archives.)

To an inmate, any object could be used to aid in escape. Homemade tools were often an inmate's best chance of getting out of the prison. Made from stolen, found, or discarded objects, these makeshift tools sometimes worked as well as the real thing. In 1926, the pictured tools were recovered in cell block 11 from four inmates who were attempting to dig a tunnel out of the jail. This image was donated by ESP's friends of CAMA-PA. (Courtesy of the Eastern State Penitentiary Historic Site Archives.)

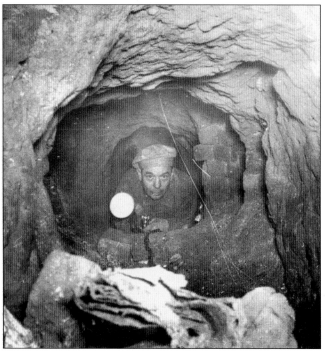

An Eastern State Penitentiary guard explores an escape tunnel discovered underneath cell block nine. When the prison opened in 1829, it was said to be escape proof. This was not true. Over the years, there were approximately 100 escapes from the prison. After a series of attempted tunnel escapes in the 1920s, all of the wooden floors remaining in the cells were replaced with stone and concrete. This image was donated by Emily Rafter, Mary B. Marden, James J. Farley, Kate Farley, Bernard C. Farley, and John P. Farley. (Courtesy of the Eastern State Penitentiary Historic Site Archives.)

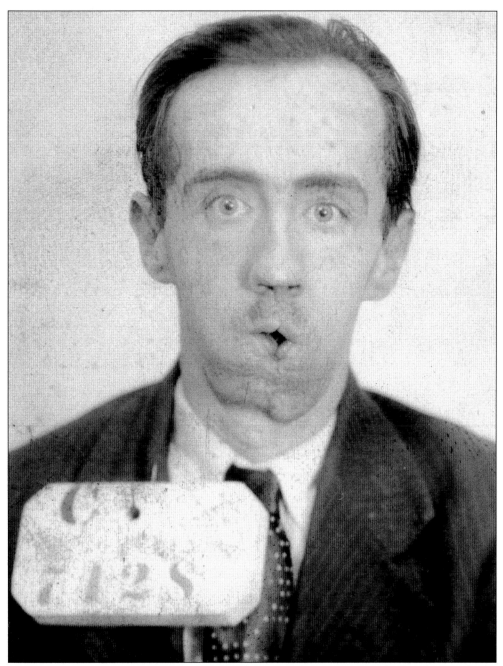

For some inmates, escape meant staying in the prison but escaping with their lives. Charles Haney, inmate No. C7428, was sentenced to "suffer death by electricity" for the crime of first-degree murder. In 1931, the 28-year-old Haney was lucky, and his sentence was commuted to life imprisonment. His intake card describes a lower jaw deformed from a gunshot wound. This image was a gift from an anonymous donor. (Courtesy of the Eastern State Penitentiary Historic Site Archives.)

Victor Andreoli arrived at Eastern State Penitentiary in 1937 at the age of 22, serving a life sentence for first-degree murder. He and an accomplice shot and killed a member of the state police. Andreoli was previously known as "Babe," he became D-2515 after entering the notorious Philadelphia prison. This was donated by the family of Capt. Andreas Scheerer. (Courtesy of the Eastern State Penitentiary Historic Site Archives.)

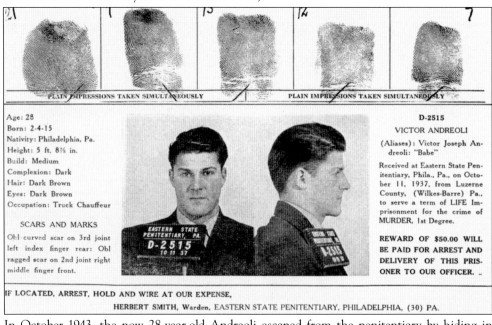

In October 1943, the now 28-year-old Andreoli escaped from the penitentiary by hiding in a truck that was exiting the building. It was rumored that the driver of the truck had also served time in Eastern State Penitentiary. This wanted poster contained Andreoli's mug shot photographs, fingerprints, and a complete physical description of the escaped convict. This was donated by the family of Capt. Andreas Scheerer. (Courtesy of the Eastern State Penitentiary Historic Site Archives.)

Eventually the state police caught up to Andreoli at a diner in Chester, Pennsylvania. Andreoli managed to fire one shot at the officers before his gun jammed, leaving him vulnerable as the police fired back. Andreoli was shot three times and killed. This image was donated by the family of Capt. Andreas Scheerer. (Courtesy of the Eastern State Penitentiary Historic Site Archives.)

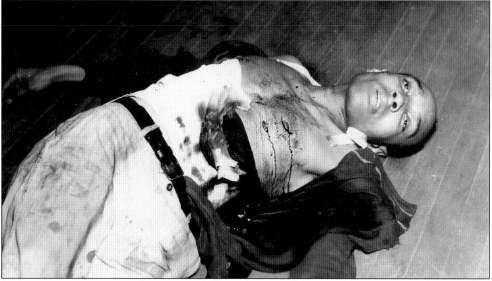

Inmate against inmate violence became a constant problem once Eastern State Penitentiary started to become overcrowded in the early 1920s. There were numerous instances of inmates settling feuds and enacting revenge when the guards were not around. Former guard Richard Griffin recalls, "Some guys were bullies and they thought they could do this and do that. But a few of them got shanked themselves. I mean, you know, this was like a city within a city." This photograph was donated by the family of Capt. Andreas Scheerer. (Courtesy of the Eastern State Penitentiary Historic Site Archives.)

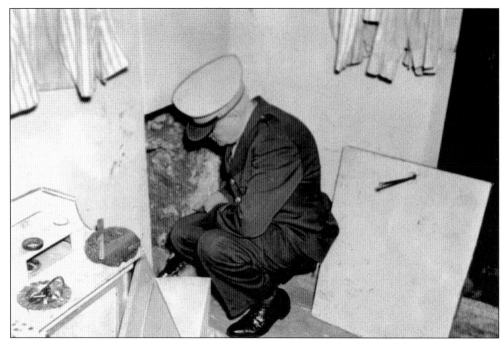

Guard Harry Parkinson inspects cell 68 in cell block seven, the onetime home of inmate Clarence Klinedinst. Hidden behind a fake wall panel was the entrance to the escape tunnel that was used by Klinedinst and 11 others, including the infamous bank robber Willie Sutton. The tunnel extended 15 feet down and then 97 feet outward, before turning up and exiting onto the prison's front terrace. It was supported by stolen wood, and a string of electrical lights ran the length of the tunnel. (Courtesy of Temple University Libraries, Urban Archives, Philadelphia, Pennsylvania.)

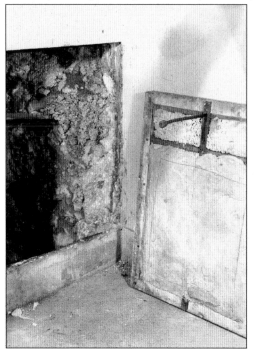

The excavated dirt and stone was slowly trickled down the toilet and into underground pipes. In order to exit the tunnel, the inmates had to completely submerge themselves in water to bypass the lowest part of the prison's outer wall. At some points, the tunnel was as narrow as 18 inches. This photograph was donated by Leonard Bojanowski. (Courtesy of the Eastern State Penitentiary Historic Site Archives.)

Was this the way to freedom? Not for very long. Of the 12 inmates to make it through the tunnel, 6 of them were recaptured that same day. Sutton was out for barely five minutes when the police found him about two blocks from Eastern State Penitentiary. (Courtesy of Temple University Libraries, Urban Archives, Philadelphia, Pennsylvania.)

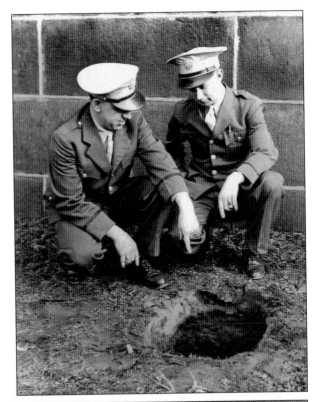

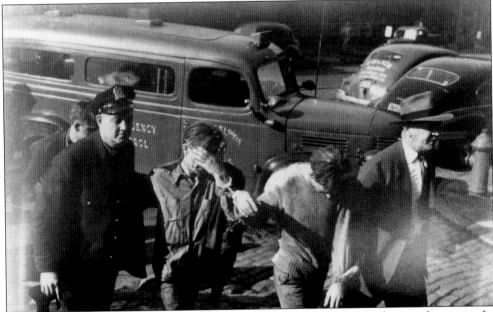

The sopping wet figures of Sutton and Robert McKnight are led back into the prison by guards. McKnight was apprehended along with Horace Bowers, who had been shot by police when they encountered the duo. To the far right is officer Walter Tees. Tees would later become warden of the penitentiary. (Courtesy of Temple University Libraries, Urban Archives, Philadelphia, Pennsylvania.)

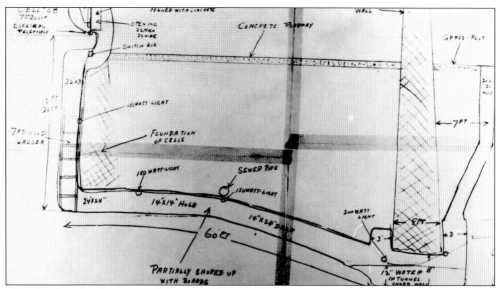

Shortly after the discovery of the tunnel, a guard was sent into it to map out the path of the escape tunnel. He produced this drawing after entering into it. Not only were prison officials shocked to discover the existence of the tunnel, but they marveled at the complexity of it as well. Clarence Klinedinst had gone so far as to set up fans inside of the tunnel to keep him cool during long nights of digging. This was donated by the John D. Shearer family. (Courtesy of the Eastern State Penitentiary Historic Site Archives.)

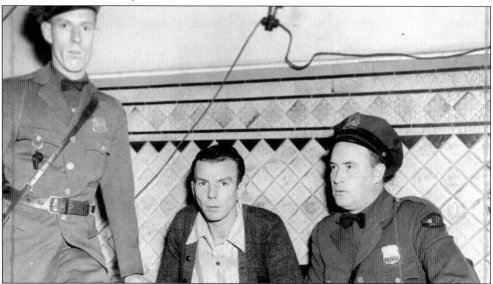

Before arriving at Eastern State Penitentiary, Klinedinst, alias Paul Sellers, worked as a plasterer and as a stone mason. Forgery, bribery, and larceny landed Klinedinst in prison where his job skills made him a valuable trustee; he did repairs all around the penitentiary and became friendly with the warden. The shy Klinedinst mostly kept a low profile, until April 3, 1945, when he and 11 other inmates escaped through a tunnel that had been dug from Klinedinst's cell. Klinedinst was recaptured within a couple of hours in north Philadelphia. A shame considering that he was up for parole in six months. (Courtesy of Temple University Libraries, Urban Archives, Philadelphia, Pennsylvania.)

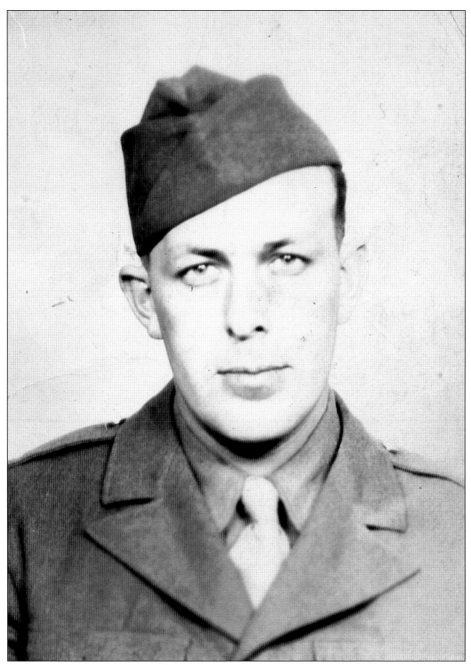

William Russell was also one of the escapees in the tunnel from cell 68. Considering he shared the cell with Klinedinst, he was certainly aware of the tunnel's construction, though his exact role in the escape is unknown. After fleeing the prison, the 29-year-old Russell traveled to northeast Philadelphia to visit an ex-girlfriend. Unfortunately for Russell, more than just his ex-girlfriend was waiting for him. The girl's father was a police officer and a trap had been set for Russell. Despite his disguise as a sailor, Russell was ambushed and shot multiple times. He survived the attack and recovered in Eastern State Penitentiary's hospital ward. This photograph was donated by Leonard Bojanowski. (Courtesy of the Eastern State Penitentiary Historic Site Archives.)

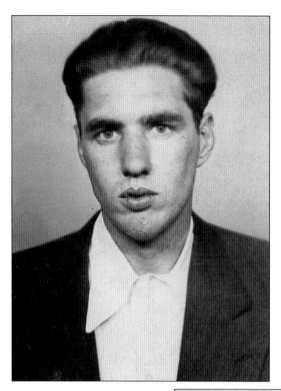

As 1 of the 12 inmates in the tunnel escape, James Grace came back to the prison under very unusual circumstances. Eight days after escaping, Grace returned to Eastern State Penitentiary on his own, knocked on the front door, and asked to be let back in. Apparently he had grown tired of life on the run. This image was a gift from Leonard Bojanowski. (Courtesy of the Eastern State Penitentiary Historic Site Archives.)

Inmate David Aiken briefly escaped from his 10–20 year sentence for armed robbery when he fled with 11 others during the tunnel escape. Aiken was recognized on a train platform several days after the escape and turned into the authorities. This image was a gift from an anonymous donor. (Courtesy of the Eastern State Penitentiary Historic Site Archives.)

EASTERN STATE
PENITENTIARY, PA
C · 9523
4 3 45

A braggart and flagrant self-promoter Willie Sutton was quick to claim credit as the mastermind of the 1945 tunnel escape, though there is little evidence to support his claim. One of the last of the 12 men to escape, Sutton was also one of the first to be recaptured. Several minutes after escaping, two police officers found him just a couple of blocks from the penitentiary. In 1946, Sutton was transferred to Philadelphia's Holmesburg Prison, from which he promptly escaped (along with fellow Eastern State Penitentiary escapee Frederick Tenuto) and became number one on the FBI's most wanted list for doing so. He was recaptured several years later in New York. Sutton also served time at New York's Sing Sing and Dannemora prisons. Earlier in his criminal career, Sutton had also managed a daring escape from Sing Sing, from which he was still at large when arrested in Philadelphia.

Shortly after this picture was taken, Fredrick Tenuto and James "Botchie" Van Sant exchanged their dapper suits for striped ones. The last remaining escapees from the 1945 jailbreak, Tenuto and Van Sant were apprehended in Brooklyn about two months after getting out of Eastern State Penitentiary. The two had gotten involved with some other criminals and planned to rob a bank, but authorities reached them before they had a chance. This photograph was donated by the family of Capt. Andreas Scheerer. (Courtesy of the Eastern State Penitentiary Historic Site Archives.)

Van Sant earned the nickname "Botchie" for his propensity to botch up crimes, a skill that also earned him a trip to Eastern State Penitentiary. Van Sant was serving 10–20 years for the shooting of a liquor store clerk in 1938. After his escape and recapture during the 1945 tunnel escape, Van Sant wrote a poem titled "The Leaky Pen," chronicling the doomed escape. It begins, "Twelve of the boys in the Eastern Pen/Were serving their time that had no end/When out of nowhere there appeared a hole/Which Kliney had dug- just like a mole." This image was donated by Leonard Bojanowski. (Courtesy of the Eastern State Penitentiary Historic Site Archives.)

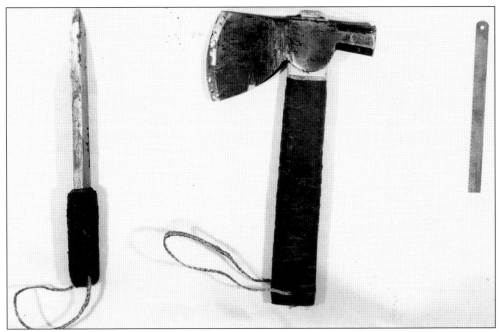

Inmates had to be creative if they were going to beat the system. Homemade prison knives, known as shivs or shanks, could be created from any number of tools or objects from around the prison. A skilled prison craftsman could transform a piece of metal and a plastic comb into a deadly weapon capable of helping an inmate fight his way to freedom or revenge. This image was donated by the family of Capt. Andreas Scheerer. (Courtesy of the Eastern State Penitentiary Historic Site Archives.)

Illegal zip guns functioned more as slingshots than as guns, using a rubber band to hurl nails, rocks, or glass at an opponent. They were often designed to mimic the shape of a gun in order to deceive people into thinking that the inmate was more armed than he actually was. A plaster mold of an inmates face could be placed in an inmate's bed at night to make a guard think the inmate was asleep when they were actually plotting ways to escape. (Courtesy of Temple University Libraries, Urban Archives, Philadelphia, Pennsylvania.)

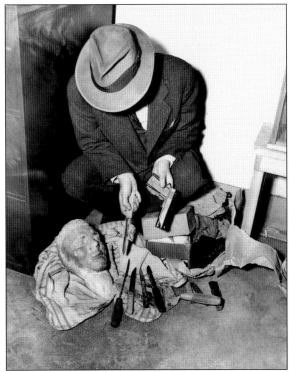

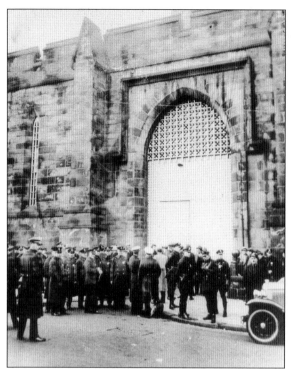

With its unusual location in the center of a major American city, Eastern State Penitentiary posed security issues for the surrounding neighborhood. This photograph shows a large police presence massed around the prison, preparing to put down a riot in 1933. As both the city and the prison grew in size, they began to encroach on one another, creating tense situations that most prisons never had to deal with. (Courtesy of the Eastern State Penitentiary Historic Site Archives.)

On January 8, 1961, Eastern State Penitentiary was confronted with the largest riot in the history of the prison. While being led back to his cell from his job in the prison mess hall, inmate John Klauzenberg tricked a rookie guard into opening the cell of another inmate, thus beginning a chain of events that would ultimately free about 800 prisoners from their cells. What started as an escape attempt for a small group of inmates turned into a free for all as the prison records room was set on fire, phone lines were destroyed, and several guards were stabbed as the inmates ran amok throughout the facility. This image was donated by the Biedermann family. (Courtesy of the Eastern State Penitentiary Historic Site Archives.)

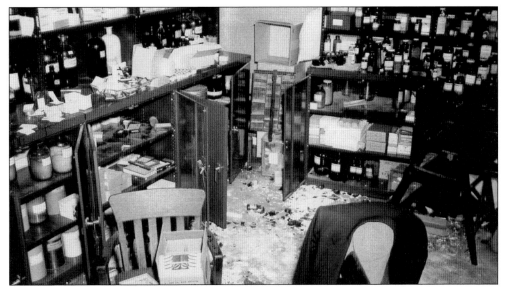

Some of the rampaging inmates from the 1961 riot found their way into the prison's pharmacy. Inside they helped themselves to drugs and other supplies before trashing the room. Operation "Prison Breakout" was put into effect, and eventually the uprising was quelled by the combined efforts of prison guards, city police, and state troopers. After this event, Eastern State Penitentiary was declared by the district attorney to be a danger to all people living in the city. This photograph was donated by the Biedermann family. (Courtesy of the Eastern State Penitentiary Historic Site Archives.)

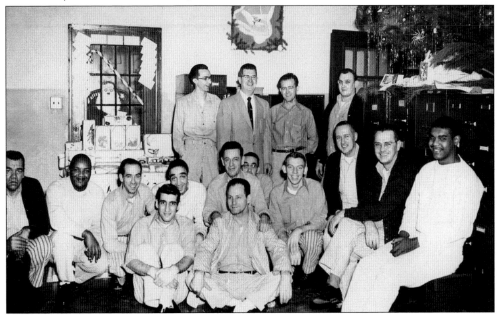

Joseph Brierly was the deputy warden at the time of the 1961 riot. Brierly was the first prison official on the scene of the riot and coordinated much of the response. He would later become warden. In this photograph, Brierly (center, with suit on) poses with a group of inmates. This image was donated by the Biedermann family. (Courtesy of the Eastern State Penitentiary Historic Site Archives.)

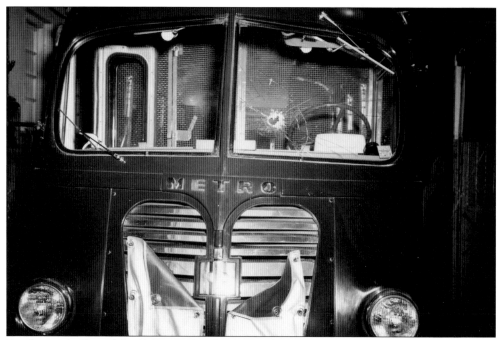

For the ringleaders of the 1961 riot, the ultimate goal was escape from the penitentiary. The plan was to steal a truck from the garage, drive it up to the wall, and then use a rope to climb over the wall. Ultimately the escape plan failed when the rioters had a confrontation in the garage with a group of police officers sent into the prison. Armed with meat cleavers the prisoners fought back, but were overpowered by the larger and better armed forces. This photograph was donated by the Biedermann family. (Courtesy of the Eastern State Penitentiary Historic Site Archives.)

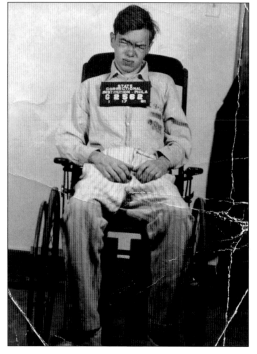

In order to put down the 1961 riot, police and state troopers had to resort to harsh tactics, the result of which is shown on the face of this inmate. No inmates were killed during the uprising, though the pictured inmate suffered a fractured skull and was administered the last rights from a chaplain in anticipation of his imminent death. This inmate's family was notified of his condition and allowed to visit him the night of the riot. During the riot, several inmates took guards hostage and switched uniforms with them. Not taking any chances with the rioters, police locked up anyone free inside the prison, guards and inmates alike, and sorted out the details later on. This photograph was donated by the Biedermann family. (Courtesy of the Eastern State Penitentiary Historic Site Archives.)

Five

RUIN AND REBIRTH

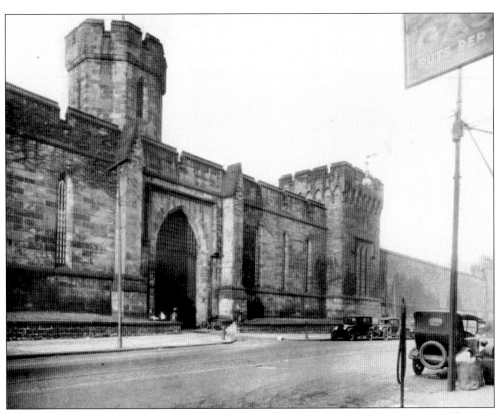

In 1965, Eastern State Penitentiary, while still an active prison, was declared a national historic landmark. This image was from the 1925 annual report.

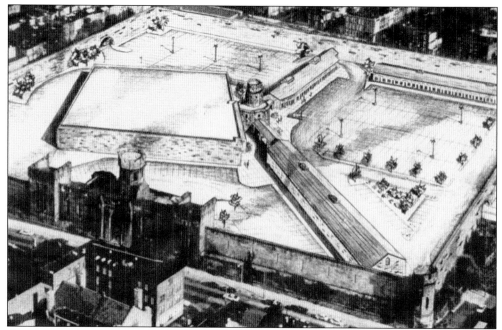

Once it was closed, Eastern State Penitentiary entered into a period of abandonment where the building sat unused on the cusp of center-city Philadelphia. Throughout the 1970s and 1980s, city officials listened to many ideas for its reuse and finally offered it for sale. Developers suggested condominiums, mixed commercial, and artist lofts. Above is a proposal for turning Eastern State Penitentiary into a walled community with housing and shops. Only the exterior walls would have remained. (Courtesy of the Eastern State Penitentiary Historic Site Archives.)

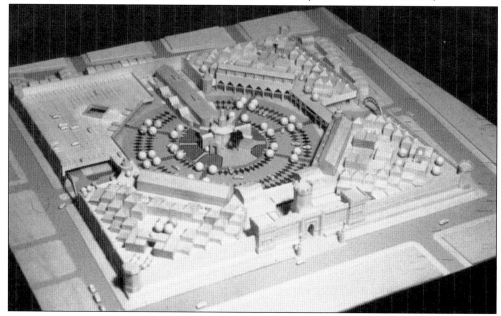

Most of the redevelopment designs incorporated some element of the original structure. In this design, the walls and center hub were kept intact, while most of the cell blocks were demolished to make rooms for condominiums. (Courtesy of the Eastern State Penitentiary Historic Site Archives.)

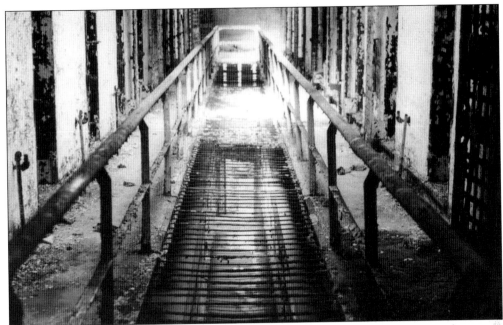

After over 20 years of abandonment, the deterioration of the prison was so severe that it was declared to be a semi-ruin. Eastern State Penitentiary was named to the National Park Services' list of endangered landmarks by Congress and in 1996 and 2000, it was added to the list of 100 Most Endangered Sites List by the World Monuments List. Due to progress in stabilization, Eastern State Penitentiary was removed from the World Monuments List in 2002. (Courtesy of the Eastern State Penitentiary Historic Site Archives.)

Today the goal of Eastern State Penitentiary Historic Site is not to restore the site, but to preserve it as a stabilized ruin. Restoration would be cost prohibitive, but most importantly the decay of the building has been well received by the public. Selected areas have been restored in order to better interpret the history of the institution. (Courtesy of the Eastern State Penitentiary Historic Site Archives.)

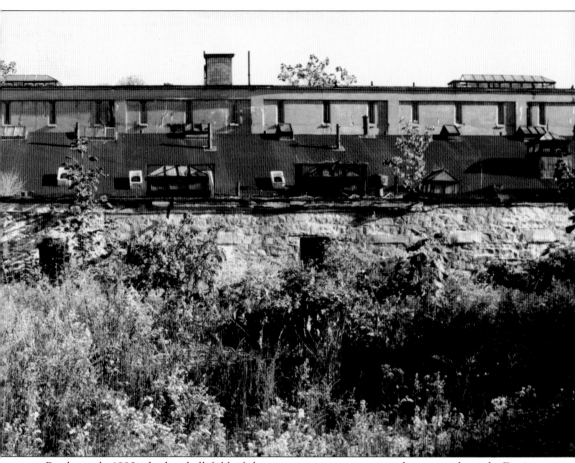

By the early 1990s the baseball field of the prison was overgrown with trees and weeds. During the almost 25 years of abandonment, nature reclaimed the spaces with surprising speed. Both cell blocks 3 and 14 had their structures weakened by the overgrowth, as evidenced by the trees growing from their rooftops. (Courtesy of the Eastern State Penitentiary Historic Site Archives.)

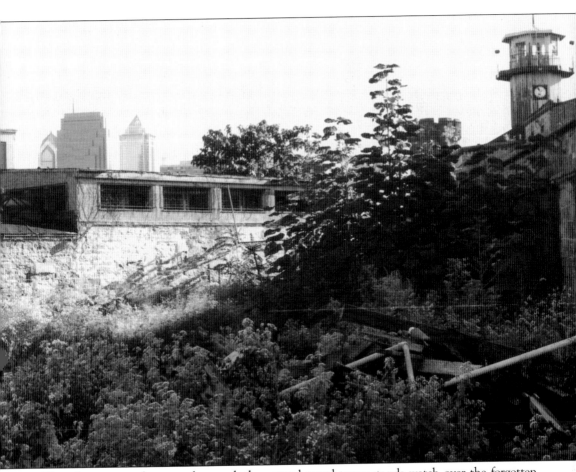

Though now rusted over and unused, the central guard tower stands watch over the forgotten prison below in another early 1990s view. To the south, the modern skyline of Philadelphia rises over the walls of the prison. (Courtesy of the Eastern State Penitentiary Historic Site Archives.)

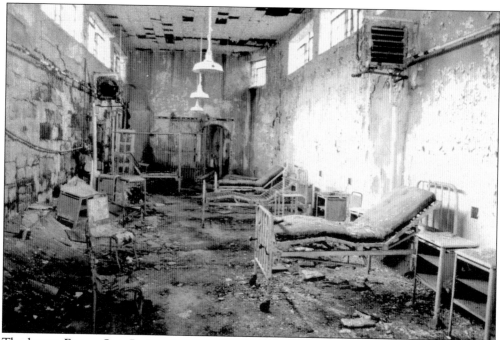

The doors to Eastern State Penitentiary were closed in 1971. Left behind was a building of extraordinary historical and architectural value that crumbled into ruin. Trees grew in what were cells, and plaster peels from the walls to reveal the stone skeleton of what was once one of the country's greatest building projects. (Courtesy of the Eastern State Penitentiary Historic Site Archives.)

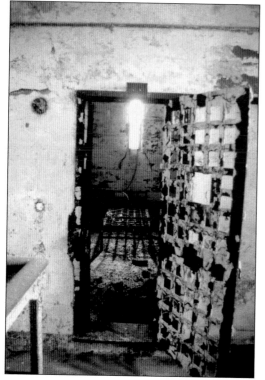

Visitors to the historic site are attracted to the eerie ruin, fascinated by the deterioration of the mighty prison and intrigued by the lives of past inhabitants. (Courtesy of the Eastern State Penitentiary Historic Site Archives.)

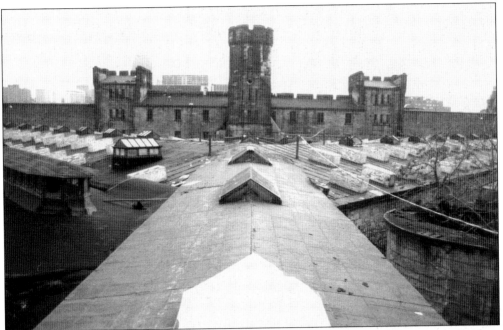

Left behind were remnants of the lives of the individuals who inhabited the prison. Artifacts such as papers, letters, boots, shoes, and furniture all tell the stories of the building's former residents. (Courtesy of the Eastern State Penitentiary Historic Site Archives.)

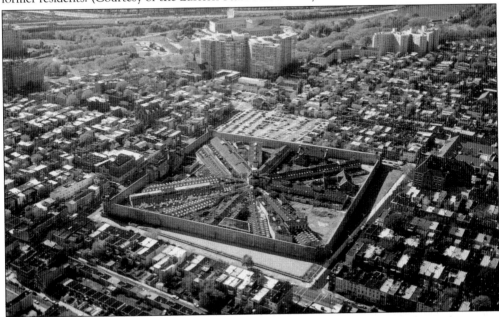

Abandoned by the city and forgotten by historians, Eastern State Penitentiary became a dispatch site for the city of Philadelphia. Housing old cars and seldom-used equipment was the only function during the 1980s of the once state-of-the-art facility. When the Eastern State Penitentiary Task Force entered the building in the early 1990s, they were confronted by an urban jungle that had gone unchecked for almost 20 years. (Photograph by Andrew J. Simcox; courtesy of the Eastern State Penitentiary Historic Site Archives.)

During Eastern State Penitentiary's years of abandonment, one of the few people to come inside the walls was Dan McCloud, a worker for the city. While inside, McCloud observed a large population of feral cats living in the building. For years, McCloud returned three times a week to feed his jailhouse cats, believing it was his duty to take care of all God's creatures. Eventually the cats died off, and in 2003, McCloud passed away. (Courtesy of the Eastern State Penitentiary Historic Site Archives.)

In 2004, artist Linda Brenner's *Ghost Cats* art installation was installed at the historic site. The *Ghost Cats* installation serves as a memorial to both the cats and to McCloud, nicknamed the "Cat Man." (Photograph by Andrew J. Simcox; courtesy of the Eastern State Penitentiary Historic Site Archives.)

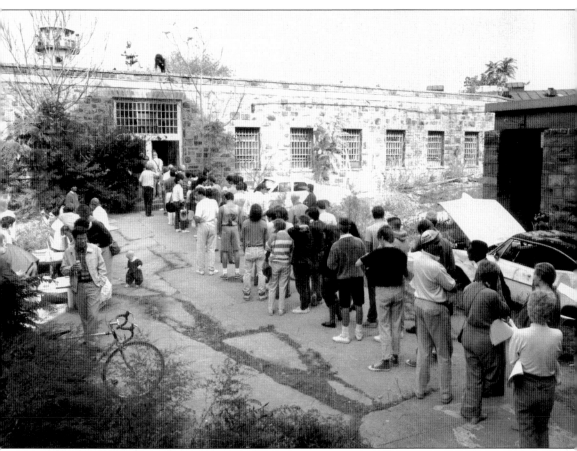

For years, the prison sat abandoned in the center of Philadelphia. Many locals passed it each day, but the prison was inaccessible to all but a few people. When the Task Force opened the penitentiary for occasional tours in the early 1990s, there was an immediate demand to see the inside of the ominous structure. (Courtesy of the Eastern State Penitentiary Historic Site Archives.)

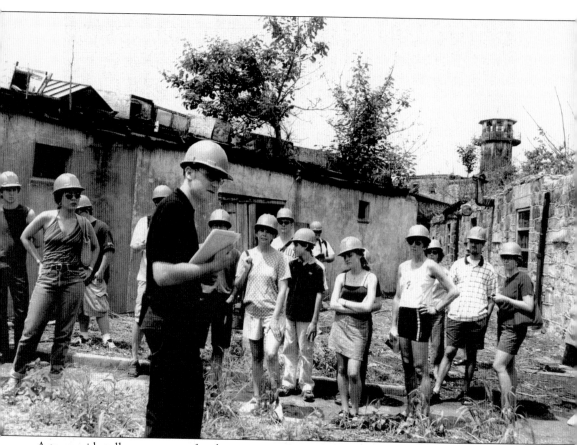

A tour guide talks to a group of early visitors in the yard behind the greenhouse. When Eastern State Penitentiary first opened for historic tours in 1994, all visitors were required to wear a hard hat due to the condition of the building. By 2003, stabilization efforts eliminated the need for hard hats. (Courtesy of the Eastern State Penitentiary Historic Site Archives.)

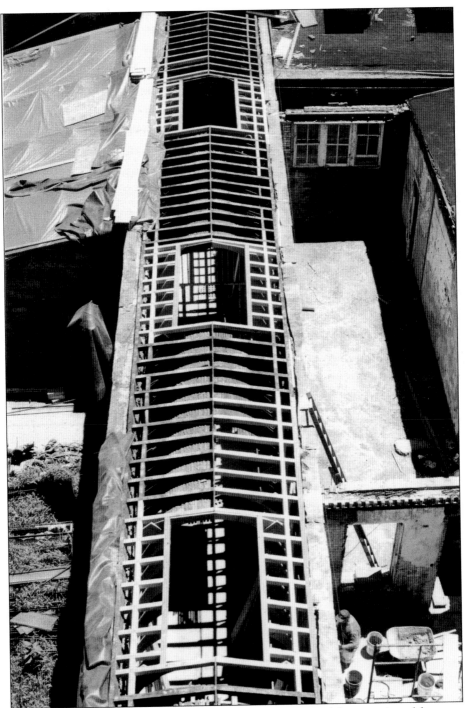

One of the largest problems facing the prison today is the continued deterioration of the structure. Years of abandonment left rotted roofs, broken windows, and collapsed walls, all of which have threatened the integrity of the building. In this photograph, cell block one is having a new roof placed atop it in order to stabilize the structure and make it safe for the visitors. (Courtesy of the Eastern State Penitentiary Historic Site Archives.)

Many people still remember the active years of the penitentiary, and the historic site draws upon this oral history to discover the past of the prison so that it can interpreted and shown to the public. Every year, former inmates, guards, and workers from the prison return for an alumni reunion. Former guard Richard Griffin (left) speaks with Joseph Corvi, a former inmate. (Courtesy of the Eastern State Penitentiary Historic Site Archives.)

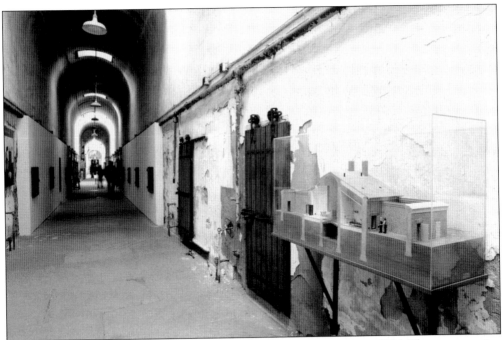

Eastern State Penitentiary has been open for daytime historic tours since 1994. The programming has expanded over the years and now features an audio tour, guided tours, and special events. It is a thriving tourist attraction located in Philadelphia's Fairmount neighborhood. (Courtesy of the Eastern State Penitentiary Historic Site Archives.)

Aside from over 150,000 visitors a year, Eastern State Penitentiary also attracts a great deal of attention from film and television crews. Since its abandonment, the prison has hosted cameras from CNN, BBC, History Channel, Discovery Channel, Sci-Fi Channel's *The Ghosthunters*, MTV's *FEAR!*, Food Network's *Emeril Live*, and many others including a music video for famed Philadelphia punk rock band The Dead Milkmen. Eastern State Penitentiary has also been the set for Hollywood productions like *12 Monkeys* and *Return to Paradise*. (Courtesy of the Eastern State Penitentiary Historic Site Archives.)

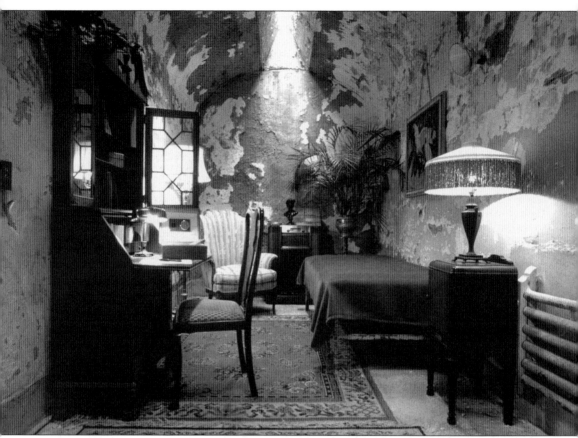

According to several newspapers of the day, Al Capone's cell was the lap of luxury, containing carpets, lamps, and a radio that he used to listen to waltzes. In the late 1930s, many years after Capone was released, several former guards from Eastern State Penitentiary visited Capone in Chicago and were treated to a good time by the famous mobster. Capone was housed in an area of cell block eight known as "Park Avenue." His cell was recreated in 2002. (Photograph by Tom Berault; courtesy of the Eastern State Penitentiary Historic Site Archives.)

In the spring of 2006, Eastern State Penitentiary Historic Site invited John Milner Associates archeologists to the prison to search for the remains of the 1945 escape tunnel. After the discovery of the tunnel prison in 1945, officials claimed to have blocked up both ends and filled the body of the tunnel with ash. The story unearthed by the archeologists was quite different. Using state-of-the-art, ground-penetrating radar and a mobile "rover" camera visitors to the site were shocked to see the tunnel still intact 61 years after being constructed; even the wooden bracing set up by Klinedinst remained. (Courtesy of the Eastern State Penitentiary Historic Site Archives.)

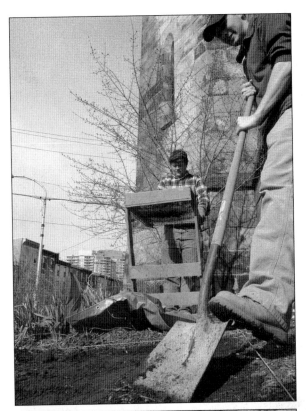

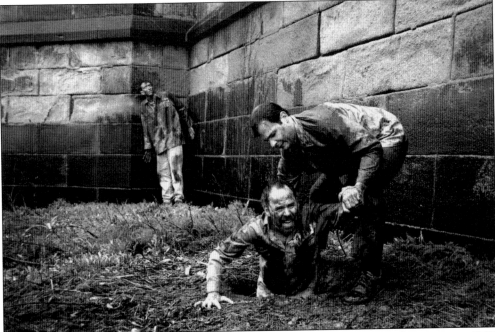

From left to right, actors Andrew Firda, William Rahill, and Ralph Edmonds are seen in INH Theatre's production of *Tunnel*, a reenactment of the 1945 tunnel escape. (Photograph by Randall Wise; courtesy of the Eastern State Penitentiary Historic Site Archives.)

A summer tradition in Philadelphia, each July the historic site stages a reenactment of the storming of the Bastille, the infamous French prison overthrown during the French Revolution. A street fair, a real guillotine, and cakes (as in, "let them eat cake") catapulted off the roof of the prison make this a memorable event. Seen here is Jim Mosetter of the Fort Mifflin Historical Society. (Courtesy of the Eastern State Penitentiary Historic Site Archives.)

Terry McNally as Marie Antoinette is led from the "Bastille" by reenactors from the Fort Mifflin Historical Society. (Photograph by Andrew J. Simcox; courtesy of the Eastern State Penitentiary Historic Site Archives.)

In 1991, even before the start of the historic tour program, the Eastern State Penitentiary Task Force, the City of Philadelphia, and neighborhood restaurants held a one night "Halloween Party" inside the prison as a fund-raiser. Building on the success of the event, a Halloween fund-raiser was held in the prison each fall. In 1995, the event was branded as *Terror Behind the Walls* and transformed the real prison into a massive haunted house. Today Terror Behind the Walls is one of the largest haunted houses in the world and is the single biggest source of revenue for the historic site. The event runs from mid-September through Halloween. (Photograph by Andrew Garn; courtesy of the Eastern State Penitentiary Historic Site Archives.)

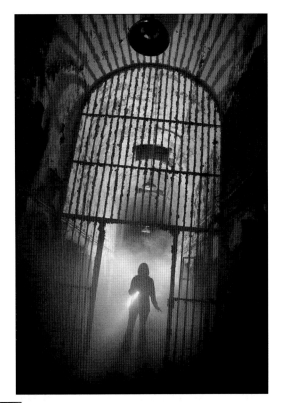

Every fall, two gargantuan gargoyles perch themselves atop the gothic facade of the penitentiary to mark the arrival of *Terror Behind the Walls*. The massive Eastern State Penitentiary may be the best location in the United States for a haunted house. It has grown to be one the nation's most recognized haunted attractions and has been called "perfect for Halloween" by the *New York Times* and consistently ranked as one of the top 10 haunted houses in the United States by *AOL City Guide*, the Travel Channel, and *HauntWorld Magazine*. (Photograph by Douglas Alan Bailey; courtesy of the Eastern State Penitentiary Historic Site Archives.)

www.arcadiapublishing.com